I bought your book *Art Marketing 101* three months ago and have worn the pages out already! Excellent book. Very glad I found it. *Stacy Lord, MA*

I have about a dozen books on the business of art, and yours is by far the most useful and most complete. Thank you for writing this fine book. I will recommend it whenever the opportunity presents itself. *Frank Hoffman MT*

I don't know how any artist can run a business without you. *New York, NY*

I've been studying the book *Art Marketing 101* and have begun to implement many of the ideas and suggestions. It's my studio Bible! *Karen Henzey, MD*

I just finished reading, highlighting and taking notes on your book *Art Marketing 101*. I must tell you how much I have enjoyed and digested the vast information that was collected to form this book. Out of the 25 years that I have been a watercolorist/instructor, this has been one of the best books I have read. I plan on recommending it to my students and to the members of my art league. *Kathy Rathburn, IN*

I just finished reading *Art Marketing 101* and loved it. Now I'm going back to start initiating what I've learned. I wish I'd known these things years ago. *Jenison, MI*

The best marketing book I've ever seen and I've read many! Clear, concise and organized. *Bala Cynwyd, PA*

I love your book *Art Marketing 101*. Thank you for writing it. I've written to my artist friends that they must buy it. *St Croix, USVI*

Thank you for such an excellent book. I enjoyed the concise, straightforward way it was written. *Naperville, IL*

I have just finished reading through *Art Marketing 101*. Thank you so much!!!! I love this book and it will be my pleasure to recommend it. I am trying to learn all I can and find my niche. Your book was so helpful. I am now starting to read *Art Licensing 101*. *Nashville, TN*

How much time, money and heartache could have been saved had I had a copy of *Art Marketing 101* years ago. At last the fog has lifted! *Long Beach, CA*

I highly recommend this book for beginning, emerging and established artists as a reference source for many different topics, as well as for an emotional support. *Los Angeles, CA*

Absolutely everything artists need to know in order to sell their creative work in today's competitive marketplace. Full of excellent tips, practical information and reference material. A must for every artist who wants to make more money. *Art marketing consultant*

Wow! Here's how good this book is - before I could write this review, I went online and ordered it. That's a first for me. Constance tell you everything about marketing your art in a clear, friendly and well-written manner. She advises you to read the book from start to finish and make notes to yourself in the wide margins. Even if you've been selling your art successfully for many years, you will learn a great deal in these pages. As soon as my copy arrives, it and a pencil are going on my night table and I'm starting again at page one. *Alice Korach, The Bead Bugle*

I just finished reading *Art Marketing 101* and loved it. Now I'm going back to start initiating what I've learned. I wish I'd known these things years ago. *Susan Burton, MI*

Art Marketing 101 is in the ALA's library and mine. It's a great book and I'm already learning lots I thought I already knew! *Ann Dentler, LA*

I used your book to create a marketing plan to procure government funding, and it worked! I've received a grant that will enable me to survive for one year while I start to sell my paintings. Thank you! *Artist, Nova Scotia, Canada*

When an artist friend of mine told me about your 101 book, well, to be honest, I felt my bowels shift and thought, "Oh, God, not another one of THOSE books!" For some strange reason I went out and bought it. I guess I must really respect this artist friend of mine. Sure enough, I found it to be a heck of a read. For your exercise on page 27 (first edition), the wildest dream that I could think up, after long and serious reflection was "Become so successful that I never have to deal with anything mentioned in this book again!" In the meantime, you're really helping to make this business far LESS painful than I ever could have imagined possible. *Paul Swift*

Thank you for such a great book. I have learned so much and continue to learn everyday. Implementing many things noted in your book. I look forward to selling my very first piece and eagerly anticipate that it happens soon. With that said, thank you, thank you, thank you for publishing your books, they provide so much direction. I am thankful to find them so early on in my new journey. *Shari Havelka*

I wanted to let you know that I read Art Marketing 101 like it was a religion. I have also shared with others who have then purchased the book. I use basically everything it says to do. I read through it every day from beginning to end (the highlighted areas). I have the goal sheet on my refrigerator and live by it. *Kip McCullough*

Art Marketing 101

An Artist's Guide to a Successful Business Plan

4th edition

Constance Smith

ART MARKETING 101, 4TH EDITION
AN ARTIST'S GUIDE TO A SUCCESSFUL BUSINESS PLAN

Fourth Edition April 2013

Copyright 2013 by Constance Smith

Cover and interior design by Laura Ottina Davis

Published by ArtNetwork Press 530.478.0920 www.artmarketing.com

ArtNetwork was created in 1986 with the idea of teaching fine artists how to earn a living from their creations.

Publisher's Cataloging in Publication (prepared by Quality Books Inc)

Smith, Constance, 1949-
 Art marketing 101 for the fine artist / by Constance Smith.--
 4th ed.
 p. cm.
 Includes index.
 ISBN 978 0-940899-80-3

 1. Art--Marketing.

 N8353.A78 1997 700.68'8
 QB196-40361

Printed and bound in the United States of America

Distributed to the trade in the United States by Consortium Book Sales and Distribution

Table of Contents

Networking

Exposure

CHAPTER 13 THE WORD

CHAPTER 14 PITCHING THE PRESS

STRATEGIC PLANNING

CHAPTER 15 CREATING THE PLAN

INTRODUCTION

This book has been empowering artists for over 20 years now. You can be one of the lucky ones to be empowered too.

It is hard for many artists to think of themselves as businesspeople. We want to make it as easy as possible to enable the artist to succeed. This is a user-friendly handbook, one that takes artists through the skills needed to create a successful business.

WHAT IS THIS BOOK ABOUT?

Developing business savvy is often viewed amongst artists as detracting from the main act of art. It's all supposed to "happen." Let's be practical! Waiting to be discovered is like waiting for Noah's Ark! This book covers office and business strategies for the furtherance of your career. Business has become more and more complex and sophisticated in the computer age. An artist must be educated in the art of business.

WHAT IS THE PHILOSOPHY OF THIS BOOK?

Artists have the right to success in this society.

WHOM IS THIS BOOK FOR?

This book has been written to give fresh ideas to emerging and professional-level artists. It is intended to help artists function in modern society, to guide them through the basic business techniques they need to know, and to gain a positive attitude toward business.

WHAT WILL YOU LEARN?

You will learn that success cannot be left to the gods. When it comes to success, you must put effort into your plan.

You will learn the basics needed to create a successful business to sell your artwork.

You will learn that marketing is a process—a continuous, ever-changing activity. Marketing is determining how and to whom to present a product.

Having a simple understanding of basic business practices—demystifying business—and creating a planned attack, will help you reach your goal. Starting and progressing in any business is a life-building experience. You can't really fail; you can only learn.

HOW TO USE THIS BOOK

The aim of this book is to make artists self-sufficient and productive in their business endeavors. How you use this book depends on how much you are committed to a career as an artist. This is not a "rah-rah" book. It's a book describing proven techniques that must be put into practice.

Treat it like a workbook. Fill in the blanks. Do one thing at a time. Start with the little things, and soon the bigger areas will become easier. I've tried to make the format simple to read, with plenty of space to jot down notes as you proceed through the chapters. Write all over the margins, as it will help you remember ideas. The detailed Table of Contents and Index should make it easy to find the exact topic you are looking for. At the end of six months, if your book is well-thumbed-through and full of scribbled notes, you're on your way to success.

Chapters are in a particular order for a reason. If you skip to the end, you will be missing some important information and won't be totally prepared for the final chapter—Creating the Plan. Even if you think you know all about a particular topic, take the time to read and reinforce what you know. You might be surprised at new ideas you discover.

Don't expect to find the one-minute magic answer in this book. Planning your marketing action takes time, open-mindedness, effort, aim, commitment, and knowledge. All kinds of information about galleries, publishers, shows, competitions, portfolios, press releases, and more will be useful in the progress of your career. Even successful artists must continue to learn in order to continue promoting their work successfully.

If it is in your heart and you want to earn your livelihood from that which you like to do most—your artwork—you will learn from this handbook that it is possible to do just that. With knowledge and strength, you will be able to make it through all the difficult times and make your dreams come true.

Most artists are problem solvers and creative thinkers—exactly who successful entrepreneurs are. So you actually have a head start as an artist heading toward developing your business. Artists have great fortitude when passionate, so you have that aspect going for you too!

Everything we do reflects who we are. In most areas of our lives, the clarity of our aim has a direct relationship to the success that we achieve. This book is intended to help you form a clear aim in the area of marketing your fine art.

Once you have the basics down and have begun working with your business plan, you will be ready for *Advanced Strategies for Marketing Art* (available at www.artmarketing.com). That book will give you guidance and suggestions on where to market, what unusual venues to consider, and how to further your career.

Good luck—and stay with it!

Chapter 1
The Psychology of Success

Roadblocks

Handling rejection

Changing your inner vision

Whatever you can do or dream you can do, begin it.
Boldness has genius, power, and magic in it. Begin it now!

Goethe

ROADBLOCKS

The business of art is a
marathon, not a sprint.

You probably didn't expect the first chapter of a book on the business of art to be about psychological preparation. Just as tennis is a psychological game, marketing is too.

When you enter the marketplace with your artwork, you'll need to have all your psychological artillery ready for action. This artillery will be crucial to taking you through the pitfalls of your business.

All of us have been raised with many attitudes that undermine our higher possibilities. Throughout our life we all must attempt to overcome those old barriers and attitudes and begin to think for ourselves—our better selves. As an entrepreneur—and that is what you are when you decide to start your own business—you will be, as defined by Webster's, "a person who organizes and manages a business undertaking, assuming the risk for the sake of profit."

ASSUMING RISK

Assuming risk is an attitude you must develop toward your art business.

▸ You will need to become aware of your personal roadblocks in order to take a risk and succeed in business.

▸ You will need to study your negative attitudes toward success to find out what might be holding you back.

▸ You must get rid of attitudes that impede you and only keep those that assist you in succeeding with your business aims. That sounds simple, but we all know it's quite difficult to change an ingrained attitude.

DON'T USE ANY EXCUSES

If you have any excuses, keep them to yourself. Don't voice them, but do note them. Excuses become more of a reality if they are voiced. Understand that they are only excuses. In case you're having difficulty seeing those excuses, here are some heard over and over.

▸ I work full-time. I don't have the time to market my artwork.

▸ I've never marketed anything before.

▸ I'm shy.

▸ I live in an uncultured town.

▸ There's too much competition.

▸ I don't know how to price my work.

▸ I don't want to part with my work.

- Financial success will poison my artwork.

- The art market is saturated.

- I don't have any business abilities.

- A true artist should be discovered.

- I would feel guilty about making money at what I love to do.

If you continue to listen to these attitudes that defeat your will, you will get nowhere. To make a living as an artist, you will need to have the courage, and take the risk, to break through your personal roadblocks. If you *truly desire* to accomplish the task of marketing and selling your art, then you will create the courage to conquer these barriers. You can. You must. There's no alternative! You've broken through barriers in other areas of your life. Break through these too.

By the way, you've already begun the process. You purchased this book because you *want* your career as a fine artist to flourish.

Myths

Artists and non-artists alike are familiar with this ubiquitous myth: Artists never make much money and don't care about money.

This is just one of the many myths that have been heaved upon the creative people of the world. Don't believe it! Peter Paul Rubens, for example, didn't believe it. He was a politician and a very good businessman.

I know many artists across America who don't believe this myth and for that reason they have prospered in the art business. They are not necessarily famous among the masses, but that isn't their aim. Their aim is to make a living as a fine artist.

You do not have to feel guilty about making money from your talents. You are fortunate enough to have a talent that can become a career. People want and need art. Get on with what you *like* to do. Have an attitude change toward the business of art. Put an end to those lies society programmed into you.

Recommended reading

Art and Fear by David Bayles and Ted Orland

Accelerating Through the Curves by Katherine Carter and Associates

Seven Days in the Art World by Sarah Thornton

The Profitable Artist by Artspire

> Conquer the myth of the struggling artist. Get on with becoming a surviving artist.

HANDLING REJECTION

80–20 Rule:
It is not meant to be that everyone will love and appreciate your art:
80% of the people will like 20% of your work.

You will need to learn to distance yourself from, yet take heed of, rejection. This is educating yourself for intelligent marketing.

- Is your presentation being rejected, not necessarily the artwork?
- Did you catch a gallery owner in the middle of a hectic day?
- Were you late to an appointment?
- Did you choose an inappropriate gallery to approach?

FEAR OF REJECTION

The fear of rejection can keep many of us from doing any given activity. Instead of taking the activity as a challenge, we begin identifying with it. This is not good.

CRITICISM

Since there is often no comment involved with rejection, just a form letter stating you were "not accepted" into a show or event, often you don't have any knowledge of why your artwork was rejected. If someone explains his problem with your artwork, you might be able to do something about it: go to a more appropriate gallery, increase or decrease the dimensions of your pieces, lower your price.

- Consulting with an art consultant may give you insight as to what the rejections might be about.
- Rethink your attitudes. Rejection is a part of any business. Use it as a catapulting place to make your marketing and artwork better.
- Be proud of yourself for not staying in the comfort zone.

Criticism can be helpful, but it can also sting. If you can listen to what people say when they comment on your work, you will be given important clues for future planning. Don't take criticism personally. If you feel your artwork is truly inspiring, other people will surely feel the same way. If you hold your artwork to a high standard—and you should if you intend to market it—why is the opinion of someone you don't even know so distressing to you? Perhaps you don't really think that your work is so good?

Without the fortitude you gain from these inevitable hurtful critiques, you may not gain the psychological strength you will need to be a success. Once you start marketing your artwork on a regular basis, this gut-level fear of criticism and rejection begins to diminish a bit. You become stronger.

Depending on who the critic is—a fellow artist, an art educator, an art professional—you will need to use your own common sense on how serious to take the critique. Listen (don't debate) and move on. Perhaps it will take you some time to realize either that it doesn't make sense, or perhaps a lightbulb will go off. Mostly

it is important to hear the words and not react. If you can do that, you have come a long way.

You will need to develop a deep understanding of your own motivation to overcome critics' words and to keep on your own path.

IMPORTANCE OF NETWORKING

For a small business such as yours, you cannot overestimate the importance of networking. If you are your own CEO—as you are when you are an entrepreneur—you will need to put on your outgoing personality at least part of the time. Look for someone you can help out in some way, and then consider what she can do for you—that is networking.

Often you will find that the cosmic rule of "six levels of separation" is true, and your new acquaintance will know the owner of the gallery in town, or an interior designer that was looking for some art. Involving yourself in a nonprofit service group, business club, or chamber of commerce can further your civic responsibility and your career.

Once you start meeting people, they will give you referrals (and you will give them referrals). It's important you follow up on these referrals promptly. Otherwise, you will be letting your acquaintance down, as well as yourself. Because of your excellent networking patterns, you will often be the "first kid on the block" to know about the professional architect who needs art for his new public building.

TIPS

Make a pact with one of your artist friends to support each other in your business quests. Together you agree on a plan—a plan for you and one for her.

▸ Perhaps you will report to her what you have accomplished for the week.

▸ You will check in with them when you are down (that gallery in New Mexico said they cannot take you on right now).

▸ You cannot get inspired today to do your marketing and need a kick in the butt.

▸ Someone's critique has really affected you.

Simplify your life: start with baby steps toward a grandiose goal. "Art is big business and I can be part of it." This is the new attitude you are developing.

17

CHANGING YOUR INNER VISION

You must define what you want. Only then can you make the effort to get it.

On the road to success you will discover many tools that are helpful to your growth. Sports trainers use visualization to help their athletes succeed. As an artist, you can also use this technique.

Visualize your artwork hanging in different venues: homes, galleries, corporations. Visualize yourself shaking hands with corporate buyers, an art publisher—whoever you imagine will help you along the way.

GOING PUBLIC

Start calling yourself an artist. You've probably considered yourself an artist for some time. Now you must announce it to the world. When someone asks you what you do for a living, your reply should be, "I'm an artist."

Once *you* start calling *yourself* an artist publicly, you'll be surprised at how many other people will start referring to you as an artist too. Hearing others call you an artist creates an inner image that reinforces your larger aim.

DEFINING SUCCESS

Do you realize that you can set your own standards of success? Wow! This is a revelation! *You* decide what success is for you—and it can, and will, change over time. Is it selling three originals in a year? Is it finding a publisher? Is it finishing ten art pieces? Is it making $25,000? $5,000?

If you want to believe what someone else tells you success should be, then you are going against the possibility of creating your own vision. Without the passion of your own heartfelt aims, you lose your inner power. You won't be able to create the passion to succeed if you use someone else's idea of a goal. Passion creates great powers within each of us and is needed to succeed in any business.

Take each year as one more step in building what *you* want—not what your mother, father, friend, or business associate thinks you need, but what *you* determine you want.

I will feel successful when _____

PERSEVERANCE

In most parts of our lives, we've found that we must persevere through troubled and difficult times. It is no different for an entrepreneur, be he artist or baker. Just to survive in life, we must persevere. To do what we want, we must really be committed.

You must plan to remain at this venture, not for one or two years, but for 10 to 40 years—all your life. You are an artist; after all, what else can you do? What else would you *want* to do for a living? With this attitude, you will be able to conquer problems when they arise.

INVEST IN YOUR CAREER

In the past, an MFA would make it legitimate for you to be an artist earning a living from selling your art. Though an MFA can be of significant help along the way, it is no longer a requirement, nor is a BA. You can receive awards, residencies, reviews, and gallery representation by being dedicated to your career. If you don't have a BA or MFA you might want to slowly approach that mark, as it could help you gain access along the way. Meeting the right people as you go through school could, indeed, mean the difference between success and never getting known.

Along the way, remember the adage, "It takes money to make money." If you are not willing to spend money on promoting yourself, why would anyone spend money on buying your artwork? You need to value your work more than anyone else does! If you are not willing to invest time, money, and energy in your career, who would be? You will need to invest in a web site, books, seminars, and other promotional tools that will help build your business. How much will you sacrifice to achieve your goals? How important are they to you? How easily do you give them up or let life take them away? You are the one to decide your fate.

Once you have the aim to have a career, you will need to spend time studying how to accomplish what you have set out to do, and you will need to spend some money—let's call it Smart Money—on important books, consultations, travel, shows, and other items to get you where you want to be. You might have to sacrifice that dinner out or that special trip to Hawaii. Decide what is most important. Eventually, you will be able to have both.

TIPS

→ If you are already established in another occupation, make your change slowly and intelligently to your new art business.

→ Get your personal life in order. You will then have the proper energy that it takes to make your business survive. Starting a new venture while your personal life is in chaos may defeat your art business aims.

→ As an artist, you will have two roles—creating art and marketing art, which includes business aspects such as organizing, selling, bookkeeping, taxes, and more.

→ You will run up against some brick walls—both in yourself and in others. It's inevitable, even for the experienced.

Present yourself as the artist you want to be, whether you've reached your goal or not. Appear successful from the get-go by how you dress, your attitude, and your web site.

A new mantra to consider:
I am not my art.

→ Take each step as it comes.

→ Try to think of competition as a good thing. It keeps you on your toes. There is space for everyone.

→ Know what you are willing to invest, money- and time-wise, in order to reach your goals.

→ Let your family and friends know your intentions of starting an art business. Also let them know that it won't detract from your responsibilities to them, though it might change these responsibilities a bit. Get their support, emotionally and psychologically. You will need it.

→ Make a total commitment or no commitment at all!

DEFEATING WILL

Probably about now a little voice is saying, "But this business stuff, I have no interest in it." You will need to start working on this voice. If you don't take an interest in your business, no one will.

Oh, but you want a rep? All the reps and gallery owners I know take an artist on after she has developed her business a bit. More often than not, you will have to start out on your own. After you have "proven yourself"—that your work sells, that there are interested buyers, then perhaps a gallery or rep will want to work with you (*Advanced Strategies for Marketing Art,* available at www.artmarketing.com, has lists of reps).

Realize that you want to start this process. Stop this voice that is defeating your aim. This business of marketing art is actually a creative venture, and you are one of the best people to take it on.

JOURNALING

Keeping a daily art journal—even an online blog—to inform you of where you are psychologically and help you in your marketing process. Note anything that you respond to in more than a passing mode: a new word you heard, an idea you had, an artwork that inspired (and perhaps why it was inspiring), a dream. Inspirations can be anything: something you read in the newspaper, words you heard, anything with synchronicity that you discover.

TIPS

→ Use the power of momentum: When something is going well, keep it going.

▸ By being organized, you create more time to spend marketing and creating. A scattered brain leads to a scattered life.

▸ Get it done early. Need to have 20 paintings done by May 30? Pretend that your deadline is April 30. Then you can relax and not be under the law of an artist who is late, tired, and a drag at an opening!

STEP-BY-STEP

As you progress with your local-oriented marketing ventures, you will be gaining knowledge that you will be able to apply in the future to your more global-oriented ventures. Every step you take will add to your confidence and approach to more difficult tasks of tomorrow. Once you have honed your local area, the nation is at your fingertips.

TAKE A RISK

To progress in any area, you must get out of your comfort zone. Try to remember a risk you took in relation to something other than business. Most likely, the courage you had to accomplish that task helped you survive whatever imaginary block you thought you couldn't overcome. You can do it again, here, now.

Have a hard time setting goals?

Try creating them when you are in an energetic frame of mind. Write them down on your master plan. When the time comes to do the project and you don't feel like it, don't back down. Go to that good frame of mind you had when you set the goal. Plunge in. Take some deep breaths and make the best of it. Just begin. You'll be breaking through a bad habit and will gain from this "pain." Opening your eyes and putting your best foot forward will guarantee surprising results.

Setting goals in your everyday life

Are you consistently rushing? Start by taking a one-day vacation from rushing. Don't make your schedule so tight. Have you ever tried not to plan a day, to just take it as it comes? Is it too scary for you to change your plans on a dime? Then going into business for yourself may also be too scary.

Try to react differently

Have you received another rejection? Try to change your automatic response: How about feeling sorry for the gallery that doesn't get to show your work? Proceed to enchant another gallery. You can't let rejections get you down. Rejections are part of any business . If you understand your larger goal, then it's not so hard to continue. Take what you've learned, get up and run another mile. Know that there is an even better situation awaiting you.

POINT TO SUCCESS

Through my years of working with artists, as well as discussing business ideas with other entrepreneurs, I have discovered that there are certain attitudes and practices that must be followed in order to arrive at success.

Attitude

The attitude of success must be held within you. The few doubts you may have must be minor. You do not fall casualty to doubts.

Investment

Most artists complain about the cost of setting up a business. Like all other entrepeneurs, you must arrive at an attitude of "investment." If you don't want to invest in your artwork, why would a client want to?

Business set up

You must have office space, tiny though it may be: a closet, the garage, your half of the bedroom. It must be dedicated to the pursuit of your career.

Time dedication

You must work 8–20 hours a week at marketing. At least half your "art" time must be dedicated to marketing.

Knowledge

You must continue to educate yourself with business-related books: *ADVANCED STRATEGIES FOR MARKETING ART, ART OFFICE, SELLING ART 101* (www.artmarketing.com). You need to subscribe to some trade journals: *ART BUSINESS NEWS, ART IN AMERICA, ARTNEWS*.

Sociable

You must be able to communicate with people. If you are afraid or timid, you must wipe away that mask. You do not have to change your personality, only your attitude about approaching people. You must attend local art shows, gallery openings, participate in your local arts council, and more. No hiding in the closet.

Plan

Dedication must be part of your attitude. You must understand that this is a lifelong career you are pursuing. It will have its ups and downs. You must envision your goal and keep at it. You must have a five-year plan. That plan must be broken down to an annual and then monthly, weekly, and daily plan, so you will have tangible aims to work with on a daily and weekly basis.

Computer literate

You must be computer literate—not necessarily a whiz kid, but literate: know how to type and print out a letter, access the Internet, send email. Knowledge of graphics programs (Photoshop, InDesign) will save tons of money during your career. The more you know, the better off you will be.

Chapter 2
Entrepreneurship

Becoming a legal business

A marketing schedule

Commitment

Taking on an assistant

Whether you think you can or think you can't, you're right.
Henry Ford

BECOMING A LEGAL BUSINESS

Once you've made your commitment to start an art business, there is *no* way around the need to learn basic business practices in order to succeed. Learning these practices is not a guarantee for success, but it is certainly the most intelligent way to approach success.

If you plan to earn a living as an artist, you must start by establishing your business as an entity. You want to become legal. This will show the world that you are serious (as well as the IRS), but more so, it will affect your inner understanding and commitment.

Take the following tasks one step at a time. They will take several hours to complete, as well as some patience and a little money. When you finish, you will be a "professionally registered artist."

- ▸ Procure a business license

- ▸ Open a business bank account

- ▸ Apply for a sales tax permit

- ▸ Get insurance

- ▸ Get a Federal tax ID

BUSINESS LICENSE

Contact your local Chamber of Commerce to find out about any license you will need for doing business. They will direct you to the correct facility. Getting a basic business license will give your new entity power. You are laying the groundwork for the future. Neglecting this detail will make your foundation weak. You can also announce to your local press that there is a new business in town.

BUSINESS BANK ACCOUNT

Open a business checking account. It will make you appear serious and professional. Use this account only for your business income and expenses. This will make it easier to keep track of your business profits. You are not required by law to have a separate account for your business, but if you ever get audited, it will make it easier to convince the IRS that you are in business. Be religious about balancing your business bank account monthly.

SALES TAX PERMIT

All states require a retail business—and that's what you are now—to collect sales tax. As a retailer you will add sales tax to your retail sales, just as a car dealer, a drugstore, or a department store would. The sales tax that you collect from customers is paid by you to the State Board of Equalization (usually annually).

When you sell wholesale to someone who resells your work—such as a gallery, rep, or interior designer—you do not charge tax. Wholesale purchasers have their own sales tax permit number—as they will ultimately retail your product (and charge their client tax). When you make a wholesale sale, you will need to take the sales tax number of the retailer and keep it in your files. If you are audited, you will be asked for that number (to prove it was a wholesale sale and you were not required to charge sales tax).

You apply for a sales tax permit at your local State Board of Equalization. A sales tax permit does not cost anything; you simply need to fill out a simple form indicating what you think you will be making in your first year of business from the sale of your artwork. Be modest. They are not holding you to any figure. They could require you to make a security deposit if you indicate that the amount of monthly sales will be substantial, so don't exaggerate.

The State Board of Equalization will give you all the information you need to know: the amount of sales tax to charge customers, as well as how to fill out your sales tax return. The sales tax office is known for auditing small businesses periodically, and they love to audit both commercial and fine artists, so keep accurate and honest records.

A resale number also allows you to buy certain products without paying taxes. Anything that becomes part of an artwork intended to be resold (paint, canvas, frame) can be purchased without paying tax. You will be asked to present your sales tax permit number when purchasing such products. Items such as easels, paint brushes, books—items that do not become part of your end product—are taxable.

INSURANCE

Examine your situation to see which types of insurance you might need: private possessions, artworks, liability, fire, earthquake, absence from work due to illness. It is possible to get coverage for your studio, business records, and artwork in progress (but perhaps not practical unless you have a significant commission in progress). Do you need all this insurance? Probably not. Find a good insurance agent, see how much it all costs, and then make an educated choice.

If you have an active studio with many people coming and going, you should consider casualty/liability insurance. The same is true if you exhibit at fairs. People could sue you if they tripped over a rug in your booth. If you work with arts councils on big commissions, they generally require you to have liability coverage.

If a work of art is lost or damaged while being delivered to a client, your homeowner's or renter's policy probably *won't* cover the loss. The insurance you need is called inland marine insurance and is usually added on to a regular policy. If you ship a lot of work, this could be a useful policy.

Do not think that sales tax is cutting into your profits. You add it on to your retail price and eventually pay that sales tax back to the state, so it doesn't affect your profit at all.

FEDERAL TAX ID

If you hire employees, you will need to apply for a federal tax identification number. If you are considering hiring help, remember: As an employer you have SDI taxes, FICA taxes, benefits, workers compensation insurance to consider. Unless you have a very good reason for hiring someone, try to work with freelancers.

The general requirements for being considered a freelancer are:

▸ Freelancers are in business for themselves—they have a business card, business license, checking account.

▸ Freelancers usually have a variety of clients they work for.

▸ Freelancers conduct their activity off your premises. They can have meetings with you on your premises, but generally they cannot do the actual physical labor on your premises.

▸ You must pay them by the job.

How much time will you devote to your creating? How much time to marketing? Have you ever actually tried to paint for eight hours a day for months on end? Most artists find it quite hard, physically as well as emotionally. One artist I know who had the opportunity to do this for a while actually injured her arm by working such long hours.

Dividing your 40-hour week (usually 60 for most of us these days!) into half—20 hours for painting and 20 hours for marketing—works out well. Of course, many of you starting out don't have 40 hours a week to devote to your new business; you are already working at a job full- or part-time.

THE 50/50 THEORY

I know you don't want to hear this, but please take heed. As a start-up business, you will need to dedicate at least half of your designated time to marketing! Even as you progress, the 50/50 theory applies. When I tell this to artists, most of them gasp. The only ones who don't choke are those who have already prospered in their career and understand this theory.

Many artists learn that they have to spend *more* than 50 percent of their business time on marketing. The time never gets shorter—it's already at a minimum at 50 percent. The only exception would be if you were able to hire someone to help you (more about this at end of the chapter).

SET SPECIFIC MARKETING HOURS

The best schedule for a part-timer is to market on the same day(s) and hour(s) each week. Marketing will then become habitual and easier. For example, if you have ten hours a week to work at marketing, work seven hours one day and three hours the next day. Take advantage of the momentum that can be created by marketing on consecutive days.

DISCIPLINE

In the case of someone who has a 9–5 Monday to Friday job that she needs to keep, here is some practical advice:

▸ Spend part of your lunchtime researching, reading, planning, contacting people.

▸ Take a risk and ask your employer for a slightly different schedule, say 7–3; or ask for a two-hour lunch one day a week, making it up on another day. Do what it takes so you can use this important time for marketing.

▸ Plan time on the weekend to do necessary research online, to attend an exhibit, or to pursue a gallery.

A MARKETING SCHEDULE

Determined people are able to accomplish remarkable things. Going into business for yourself, whether it be as an artist or carpenter, takes great determination and discipline.

You only have two hours a week to spare for marketing? Sometime Tuesday through Friday is probably best, from 10–12 or 2–4. Remember: Even with only two hours a week, you're going to get further in marketing than the person not marketing at all!

TIPS FROM WORKING ARTISTS

→ Keep making appointments. You must contact people in order to sell.

→ No desperation: Have money in your pocket so you don't have to "give in" to some ridiculously low sales price for your artwork.

→ Have integrity.

→ Have desire, always wanting to get better, both at art and business.

DAILY PLANNER

Not only must you be organized in your office setup, but you must also be organized in your personal activities schedule.

In the highly complex society that we have become, bombarded constantly with figures, ideas, facts, commitments, tasks, and deadlines, we have a lot on our minds. If you don't already have an organizer or daily planner, get one. You can download and print out some calendars at www.artmarketing.com/calendars.pdf.

When you decide on the best marketing hours for your personal schedule, remember that during these hours you can only do marketing activities—no artwork. You can write down a great artistic idea, but that's it. If you start deviating toward creating art, you are doomed. Don't do it! If you have a block during those hours, then just sit and do nothing. *Do not start creating art!*

COMMITMENT

Let your family know exactly what you intend your marketing hours to be. Request that they not interrupt you during those times. Instigate your own rules and inform them. Get respect.

Create a schedule in writing that you intend to follow. Post it in at least two places (refrigerator, computer, bathroom) to remind you of your commitment. Stick with the same time schedule: it will get you into an easy-to-accommodate routine. Whether you plan to market four or twenty hours per week, sign this contract and start today!

MY SCHEDULE

Time of day	Mon	Tues	Wed	Thurs	Fri	Sat	Sun
8–10							
10–12							
12–2							
2–4							
4–6							
6–8							

I am committed to the above hours for marketing! ___

Artist's signature _____

TAKING ON AN ASSISTANT

The glamorous thought of relieving oneself of some of the paperwork, research, and daily activities in any office by having an assistant is freeing. If you are fortunate enough to have the finances to pay for an assistant, don't hesitate to do so.

▸ Keep in mind that you will have to direct and work with this person quite closely. At first, most likely, you will have to teach her the "tricks of the trade."

▸ You will need to plan this expense into your budget for a minimum of six months.

▸ You don't want to "hire" her. Try to arrange for her to be a freelancer (see page 26).

THIS PERSON WILL NEED TO

▸ Be organized.

▸ Be familiar with the computer and have knowledge of the programs you use, possibly web site management.

▸ Be familiar with art; know some history and language.

▸ Understand the concept of marketing.

▸ Have a good phone voice as well as personality to deal with art professionals.

▸ Possibly know how to sell and close a deal.

Chapter 3

Your Office
Your Studio

Your office space

Organizing your office

Your studio space

Archiving your artwork

Creativity is an attitude.
Erich Fromm

YOUR OFFICE SPACE

To accommodate your art business, you will need to create an office environment. If it can't be an entire room—if it's only a small desk—make sure it's private, quiet, and comfortable, perhaps in a corner of your studio space. You'll be spending lots of time there. You can't work with people constantly interrupting you. Is there ample lighting? Are there electrical outlets? Heat?

Put energy into your office space. If you don't, you are not taking your business seriously, and you are neglecting an important factor for success. Set up your desk, file cabinets, and computer so they are convenient and inviting.

TELEPHONE AND ANSWERING DEVICES

The telephone is one of the best marketing tools you have. Learn how to use it. Read more about telephone sales techniques in our books *Advanced Strategies for Marketing Art* (pages 35–38) as well as in *Selling Art 101* (chapter 6). Both books available at www.artmarketing.com.

Have separate telephone lines for business and personal use. Don't give your business number to friends.

The message on your answering machine should be brief and professional, with an upbeat tone. It should include your company name and a request for callers to leave their name, phone number (with area code), and a message.

COMPUTERS

Computerizing your art business is a must. A small business without a computer these days is like a dinosaur. You'll be able to create a business presentation, resume, do your bookkeeping, time management, research, email communication, archive your work, and more. Of course, you will need a small, inexpensive four-color printer, too.

SOFTWARE

There are several reasonably priced software programs created specifically to help artists organize their offices. These are all inexpensive with a short learning curve.

WorkingArtist - You will be able to download a demo version to see if this program fits your requirements. Designed by a working artist, this software keeps track of all your office organization needs: price lists, mailing lists and labels, where you have sent what to, calendar and daily task to-dos, invoices, consignments, patron activity, and more. www.workingartist.com

Gyst - This software guides you through the business of being an artist, providing all the organizational tools and resources necessary to build and maintain a thriving art practice: grant-writing tutorial, calendar, short- and long-term planning tools,

exhibition checklists and guides, presentation and exhibition tools, legal contracts, statement and resume tutorials, mailing list creation, artwork inventory system, and more. Demo available. www.gyst-ink.com

Arttracker - A simple, comprehensive application that helps keep track of artwork. Records vital information for every piece created, print labels for mailings, keep track of inventory in each gallery in which art is held, print current inventory, create professional consignment sheets, invoices, and reports. Created by a gallery owner for artists. www.xanadugallery.com/ArtTracker/Index.asp

eArtist - A software business-management tool for artists at all stages of their careers. A professional solution designed to help artists with their day-to-day business process so they can concentrate on creating art rather than learning software programs. eArtist helps artists take control of their mailing list and contacts, keeps track of their exhibition schedules, helps document their exhibition history and artwork, and provides a professional invoice and receipt system for sales. www.artscope.net/eArtist

Artworks - Cataloging, tracking, and presentation, designed specifically for artists. This software allows you to catalog artwork, acts as a Rolodex, tracks where all your works are at the moment, and, for exhibitions and loans, when they are due back. The details of each work include photographs. You can show prospects a full-screen slide show. It captures sales details, including commissions and taxes. For PC or Mac. www.artworkspro.com

Artist's Butler - Documents and maintains an inventory of each item produced or sold, including its exhibition history, maintaining a resume to include your most recent exhibit, prepares invitations; keeps mailing lists up-to-date and sends batch email, prepares price lists and consignment sheets for customers and galleries, maintains orderly correspondence; creates a printed catalog to introduce your work to prospective galleries, and prints Certificate of Authenticity. www.lynnsoft.net

ORGANIZING YOUR OFFICE

Your home studio and office must become a sanctuary.

Some people have a tremendous problem getting organized, whether it be in their private or their business lives. Is your desk a collection of piles? Make one of your aims to keep your life easier; get organized. Know where everything is located and kept. Get rid of unnecessary clutter and items. Start thinking, "I want to have an organized studio. I want to protect my future status as an artist. I will feel less stress, sell more, have more time to create, and people will respect me and my artwork more."

If need be, take an adult education class that offers organizing techniques. Alternatively, hire an organizer for a day. Invest a little time and money getting organized and you will feel more clear about your entire business situation. You'll finally get to experience how nice it is when you can quickly find the file for which you are looking.

OFFICE ITEMS YOU'LL NEED

Office "machines" help us get and stay organized. Invest in a few.

Daily planner	File cabinet	File folders	Highlighters
Letter opener	Message pads	Note pads	Paper clips
Paper cutter	Paper shredder	Pens	Rolodex
Rubber bands	Ruler	Scissors	Stapler
Tape	Three-hole punch	Wastebasket	
Check-endorsement stamp			

FILE FOLDER SUGGESTIONS

Though a lot of items are kept within your computer, some physical files and papers will be necessary. Possibilities include:

Accounts receivable	Accounts payable	Bank account
Books to read	Clients	Current projects
Fictitious name permit	Future projects	Hot file
Idea file	Legal documents	Letters to clients
Press releases	Prospective clients	Resume
Sales receipts	Sales tax returns	Travel expenses

TO-DO LIST

A to-do list should be a list that you repeatedly review, sitting in the middle of your desk, so it pesters you. Studies show that the moment you start a to-do list, you become 25 percent more efficient!

Be sure to write down creative ideas—things you notice that you might want to use in the future. Don't vainly think you'll remember! You'll almost always forget. Did you attend an exhibit and note something about the display? The prices? Writing ideas down will free space for other things in your memory bank.

With an office setup that is efficient and easy to be in, you will start working toward your goal: having a successful art business!

The to-do list helps you set priorities and focus on important tasks.

YOUR STUDIO SPACE

As your career grows, your idea of an ideal studio will change. Take what you can get at first, and work toward your goals.

How in your wildest imagination do you envision your studio to be? Is it large enough to fit your two-story sculptures? Do you like "blank" space or a lounge area where you can think and relax? Go all out and think of the most luxurious studio you can. Describe it here:_____

Now write down where and how you can have a studio today. If you already have a studio to work in, how can it be improved for the time being?

Having a studio you feel comfortable working in is part of marketing. You need to take pride in your studio space, which will show in your face when you invite clients over.

STUDIO LOCATIONS AND TYPES

Home studio - If your studio is within your home (or next door in a garage), you will need to be disciplined enough to go to your studio at specified hours to accomplish your goals. Can your family cooperate with your needs: for example, not knock on the door unless it is an emergency? Can you escape the TV in the living room? Are your younger children taken care of by someone else?

Private out-of-home studio - There are drawbacks to having a studio outside your home environment; you have to drive to it, rental cost; oftentimes, you cannot revamp it as you wish.

Workspace within a larger artist studio - The benefits of having your studio in an art enclave can be great: You are working with like minds; sharing critiques, ideas, and techniques. Other artists can help you with your lack of discipline. You have shows together and expenses are shared. Family is not interrupting you; it's less noisy. The habit of going to work daily can really create inspiration, more product, and more marketing discipline.

No studio space to be found? Get together with a few other artists and rent a larger space to share.

Subsidized studios - Often available through a local arts council. Sometimes even art schools subsidize spaces. Perhaps you can become a "resident" artist and receive a free studio space (try a local church).

A studio space is a prime target for disorganization. You will have important visitors—collectors, gallery owners, other artists—to view your work in progress.

YOUR STUDIO TALKS TO VISITORS

Are your work areas dusty and soiled? Many people will wonder how you can work in such conditions: It doesn't leave a good impression. You certainly don't want dust-filled chairs.

Are there things strewn all over the floor? If they are in neat piles or in file containers, that's one thing. But to see sheets of ripped papers, like a cyclone hit, will imply just that to your customers. How can you work in such disorganization? Will I ever get my painting that I pay for in advance? Will he forget I paid in cash?

Is the general atmosphere of your studio congenial? Frame some of your press coverage, a testimonial, award, or an article you've written, and hang them on the wall. Though your visitors might not read them verbatim, they will heed the importance. Did you create a magazine or book cover? If so, frame it and place it next to the original.

Take pride in your studio space.

ORGANIZING YOUR STUDIO

by Kathy Gulrich

Truth is, many artists really like working in a chaotic space, and some find their most creative ideas in the midst of disorganization and mess. How about you? The more you understand how a messy studio works for you, the easier it'll be to move past the clutter, and get things organized where and when it really counts.

Look around your studio right now. If everything's neatly stored and stacked and tucked away, then skip this article. For those of you who are still here (most, I'd bet), look around once more. You're probably seeing a lot of things you should put away, reorganize, move to the storeroom, or simply clean up. Why haven't you done it? Chances are, there's something about the clutter that really works for you. That's where we'll start.

There's comfort in clutter

Many of my happiest moments in the studio were early in the morning, getting ready to carve my greenware bowls. I'd hang my coat and bag, then grab my banding wheel off the shelf and bring it to the work table. Of course, I'd have to move magazines, notes, and unfinished pots out of the way. Then I'd overfill the space with all of my tools, sketchbooks, underglazes, and brushes.

How I moved them, set them out, placed them perfectly within reach, was almost a ritual. If someone else had come in early and set up my workspace for me, I know my carving wouldn't have been nearly as beautiful—or fulfilling. It may be a bit weird, but I can tell you that my de-cluttering and then re-cluttering the space was an important part of my creative process.

Think about how or where clutter works for you. Maybe you, too, enjoy being in the midst of chaos when you create. Maybe you get a charge out of seeing how many weeks you can wait before the bisque shelves absolutely must be cleared. Maybe you like the challenge of seeing whether you can hold out longer than your studio partner to empty the kiln. Or, maybe you just enjoy sitting there looking at a really messy area and deciding not to do anything about it.

Appreciate the comfort or energy that you get from the disorganization around you. Decide, right now, to keep the clutter that's working for you. And enjoy it.

What's driving you crazy?

Not all clutter makes us feel good. For example, I still have a bruise on my leg from the corner of a wooden box I simply refused to move out of the way for weeks.

Which area of your studio bugs you the most? How would you describe it right now: too crowded, too inaccessible, or too disorganized? All three? When you're working in the studio, is it usually the little things that get under your skin (the pen that

never seems to be near the phone, or the clay that constantly clogs the drain), or are you more frustrated by clutter in general? Look around. Get a realistic picture of the problem. On a scale from 1 to 10, how disorganized is your studio?

If you scored between 1 to 5, chances are you can set things straight with just a bit of effort. If you scored closer to 10, there's probably a part of your studio that's so out of control that you don't even know where to begin to get it organized. Don't get discouraged. It can be done, and it's probably much easier than you think.

First things first

There's absolutely no excuse for clutter that's creating a safety hazard. So, if there's anything jeopardizing your safety or the safety of your employees, students, or customers, take care of it now. Your solution doesn't need to be well organized, pretty, or even permanent; it just needs to be safe.

Next, look to eliminate clutter or chaos that's affecting the financial health of your business. Are you losing students because the studio is disorganized or uninviting? Are class materials easy to access? Protected from breakage or loss? Is your inventory well displayed? Does your studio attract customers, or turn them off? Even if you work best in the midst of clutter, be sure to put your most well-organized foot forward to the public.

Where to from here?

Organizing your studio may seem to be a daunting or even impossible task, but it's not. The secret is that there's absolutely no reason to organize everything. Yes, you must take care of safety. And it wouldn't be very smart to ignore areas that affect the students or customers who support your business. But after that, how, where, when, or if you organize is totally up to you.

My suggestion

Choose an area or two that you'd like to keep cluttered and disorganized. You'll be amazed at how much better that area feels once you've decided it's okay exactly as it is. Then, choose the area that bugs you the most, and make a commitment to change it. Do something to organize it every day (or every week) until it no longer bugs you. Take a breather, then choose another area that you'd like to tackle—make it work better for you. When you're ready, tackle another area, and another, and another. You'll find that small changes can make a really big difference.

The best studio is one that reflects you, your passion, your art, and your personality. Figure out what makes you tick, then organize from the inside out.

Kathy Gulrich is an art career coach, helping artists make the transition from full-time job to full-time artist. She is author of *187-Tips-Artists-Successful-Career*.

ARCHIVING YOUR ARTWORK

As you enter into the business world, you must look at your art career with a broad perspective—at least 20 years into the future. Potential clients want to know that you will be around for a while. Most artists that are very successful do not reach their greatest success until ten to twenty years of exposure to sales.

Keeping track of your artwork—archiving—is an important factor overlooked by many artists. What happens when you are 65 and a big publisher wants to do a book about you? If you haven't kept track of your paintings (to whom they have been sold), it would be difficult to create this book. You want to organize your inventory for several reasons:

▸ When you sell a piece, keep track of the name and address of the purchaser. In the future, when you are having a retrospective, you will know where to find this important piece.

▸ If a client, in turn, sells/donates/gives away your piece, you want to be informed. Make sure your clients are educated about this.

▸ Save your sketches and minor works, especially those that have developed into major works. These can be especially useful in a retrospective show.

▸ Know what medium or special color combo you used when creating that favorite piece. Someday you or someone else might need to repair your work.

Perceiving your future place in the art world should be one of the most important factors you consider when thinking about your career. Artists need to inventory their artwork, and have detailed information about it for posterity.

Cataloging

Catalog your work, similar to how a museum would catalog its collection. Your records should tell you:

▸ Date and title of artwork.

▸ Inventory number. Develop a code—year completed, month, and code number—2013-05-44

▸ Date the work was started and completed.

▸ Who owns the piece. If a buyer sells, put the new owner's address in your files.

▸ Price you sold it for, as well as subsequent prices for which it was sold.

▸ Who sold it (you, gallery, rep).

▸ What inspired the work, costs of materials, specifics of materials used (perhaps even where you purchased them), frame type. All of this information could help

in any future restoration project. When you become known and museums start buying your work, this will help them with their archives.

▸ Know which gallery or collector has your artwork. For an artist who has paintings scattered about, know which ones are loaned to a gallery on consignment and which are still available to sell. Don't devalue your work by letting it out of your studio without keeping track. Wouldn't you feel devastated if you lost your favorite painting?

▸ Use a "Master Inventory" (page 43) to record all of your finished and unfinished work. Survival and integrity of your artwork will be more possible; curators need detailed information about each piece you've created. When you take the time and energy to document each piece, you're adding significant importance to your entire portfolio.

Can you imagine a museum curator who didn't have a form for keeping track of what artworks were in a travelling exhibit or out on loan to another museum? Of course not! They would be in deep trouble if questioned about a "missing" piece without documents to back up the whereabouts. Would you allow a gallery repping you to loan out one of your works to its client without having a signed document indicating exactly where and how long it was going to be away? Absolutely not! Nor should you allow yourself any such "privileges."

CASE IN POINT

When Ben Nicholson died, his work was coming to be worth hundreds of thousands, millions in some cases. Someone began to forge his work shortly after his death. Prices began to fall when this was discovered. Had he archived his work better, these forgeries wouldn't have been able to have been sold into the marketplace, and, thus, his artwork would have been worth a lot more.

ANOTHER CASE

One artist I know has an attitude that I hope you will develop. He did not skip documentation. He knew since he was 18 years old that he would be an artist. He did graphic design at times, comics, and a myriad other jobs related to art, which also helped his fine art career. Years ago, predigital, he kept 8x10″ transparencies of all his important works from the very beginning of his career. This artist had the attitude that he would be well known. He knew that someday a book would be published on his life and that these transparencies would be needed to produce the book. When I met him at age 62, the stack of transparencies was six feet high! He will soon have a monograph of his work published.

HISTORICAL DOCUMENTATION OF ORIGINALS

Code # _____ Title _____

Date begun _____ Date completed _____ Hours to complete _____

Price/framed _____ Price (unframed) _____ Other costs _____

Size/framed _____ Size (unframed) _____

Medium _____

Colors _____

Design description _____

Inspiration _____

Techniques used in execution _____

Materials used in framing _____

Recommendations for care _____

Photo here

EXHIBITION HISTORY

Date	Location	Date returned

PURCHASE HISTORY

Date sold _____ Cost _____

Sold to _____

Second owner _____ Date sold _____ Price _____

MASTER INVENTORY

CODE #	TITLE	MED	SIZE	STARTED	FINISHED	SOLD	PRICE	LOCATION

Chapter 4
Number Crunching

Keeping records

Accounting

Financial projections

In art, economy always is beauty.
Henry James

KEEPING RECORDS

This chapter will touch upon the topic of money and bookkeeping. You will be informed of the most important aspects of record keeping for your small business. As your business progresses, you might need to find a more detailed book on this topic. For now, however, we want to keep things simple.

THE PURPOSE OF ACCOUNTING

Though the IRS requires all businesses to file tax returns calculated from appropriate backup documents, as a business owner you want to understand that you are keeping records for your own knowledge. Yes, for yourself! Once you learn to study your accounting records, you will understand the full benefits of keeping accurate and detailed records. Good planning and budgeting are crucial in any business; they could mean the difference between success and failure.

ORGANIZING YOUR RECEIPTS

Saving receipts is key to record keeping; without them, you won't be able to record any numbers. If you do get audited (about one percent chance), you also will be sharing these receipts with the IRS.

Save all your art-related receipts, both income and expenditures, for at least five years. Also save calendars, appointment books, business cards of galleries you visit, copies of business letters you sent, press releases, awards, marketing plans you worked on, client lists, resumes, professional organizations to which you belong, and anything else that seems appropriate. If you are ever audited, you will need these records to prove that you were attempting to earn a living through the sale of your art.

TIPS

→ Keep receipts in file folders, divided by the different tax-deductible categories.

→ If you are in your car a lot, keep an envelope in your glove compartment for receipts.

→ When you save meal receipts, write the name of the person you took out and the business relationship directly on the receipt.

→ Keep one credit card for business and one for personal use.

PERSONAL TASK

Whether in your private or business affairs, it is very important to understand how you spend, as well as why and when. The following suggested task is not pleasant for most people. Perhaps that's why, if you try it, you will learn so much.

YOUR THREE-MONTH TASK

In order to see exactly how, why, and when you spend, keep track of every expenditure for at least *three* months. When you keep track for three months, you will be able to see your weaknesses regarding spending. You must write down every cent you spend: $1.25 for morning coffee, $1 bridge toll, $1 to beggar, $5 for shoe repair. I guarantee that you will be surprised by the results. When you calculate your totals for weekly, monthly, and quarterly expenditures, you will be shocked. If you know already that you have trouble balancing your personal budget, use only cash, ATM, or check—no credit cards.

ACCOUNTING

Calculate what you pay each year from bounced checks, other bank fees, interest, and past-due charges. You will be shocked.

Some of the software programs aforementioned (pages 33–34) will suffice for your accounting needs. If you find you need more advanced accounting, the best software program around, and least expensive, is Quicken. It keeps track of your income, expenses, and calculates your profit/loss statement.

INCOME CATEGORIES

Awards	Commissions	Consignment sale
Fairs/shows	Gallery 'A' sales	Gallery 'B' sales
Grant	Leases	Miscellaneous income
Royalties	Rep sales	Studio sales

EXPENSE CATEGORIES

Accounting/bookkeeping/tax preparer fees

Admissions to art museums, trade shows, conventions

Advertising, business cards, brochures

Automobile expenses

Bank fees/bounced checks

Books (this one!), videos

Commissions to reps and galleries

Consulting fees

Donations of artwork (consult your accountant)

Donations to charities, museums, nonprofits (consult your accountant)

Dues to art associations/clubs

Educational expenses related to art seminars, classes

Entertainment, business-related

Equipment/furniture/machines for your studio or office

Fees to enter competitions and trade shows

Gifts to potential clients (limited per year)

Insurance

Interest on business-related loans

Legal fees

Licenses, permits, copyright application fees

Materials (paint, canvas, brushes, frames)

Office supplies

Photography fees for publicity photos

Postage, UPS, Federal Express, packing supplies

Printing

Promotion costs (business-related dinners, wine for studio showing)

Protective clothing

Rent and utilities on studio or office (gas, electric, garbage, water)

Research and development expenses

Subscriptions to art- and business-related magazines

Telephone

Travel expenses (airfares, hotel, food, car rental, taxi) to art events such as trade shows, gallery openings, seminars, conventions, fairs

PROFIT/LOSS STATEMENTS

When you finish each month's record keeping and have calculated the totals for each category of income and expense, create a profit/loss statement (sometimes known as a P&L Statement, P/L or Income Statement). This statement gives you the bottom line on how much you made in any given period of time. When you put three months of totals together, you have a quarterly P&L Statement— probably a more viable tool for analyzing your business than a monthly statement.

This P&L Statement is the primary instrument used to diagnose your business's health and to note trends and growth in your business. You will be able to study where your income is derived from as well as where your expenditures go. It is a great help to know how to read your P&L Statement for planning future goals. If you are doing a particular project or promotion (having an open studio, doing a promo to publishers)—classify all those expenses into specific categories such as open studio/refreshments, open studio/invitations so that when you read your financial statement at the end of the quarter, you will be able to see at a glance if the special promo was profitable.

BANK STATEMENTS

After balancing your bank statement monthly, you create a P&L Statement.

SAMPLE
PROFIT/LOSS STATEMENT

JANUARY 2013

Income from sales

Gallery	$ 1500	
Open studio sales	$ 400	
Rentals	$ 125	
Prizes from contests	$ 100	
Total income		**$2125**
Cost of goods (supplies to produce artwork)		$ 375

Expenses

Advertising	—	
Auto	$ 53	
Bank charges	$ 8	
Competition fees	$ 25	
Dues/publications/books	$ 19	
Entertainment/refreshments	$ 80	
Insurance	—	
Interest	—	
Legal/accounting fees	—	
Miscellaneous	$ 40	
Office supplies	$ 25	
Personnel/assistant	$ 250	
Printing	$ 30	
Rent	$ 100	
Rental equipment	—	
Seminars	$ 50	
Shipping/postage	$ 25	
Telephone	$ 20	
Total expense		$ 725
Net profit		**$1025**

A financial projection is very similar to a financial budget. On a financial projection statement you will try to predict what income you will have in the near and distant future, as well as the expenses for that same period.

Let's say you have been accepted by Bank of the Mediterranean for a one-person show for January. Project the amount you expect to make from this exhibit (both on-site and during follow-up). Of course, you don't know exactly, but create some goals. It will help you close a sale! This projection will help you to see if you have the funds to hire a salesperson, send postcards, buy refreshments, and so on.

SOME EXPENSES TO CONSIDER

Be as specific as possible when you break down both the income and expense categories. You will better be able to decipher then precisely what created the income for you. Did the press help? Was the salesman any good? Were you so busy you ran out of refreshments?

Some expenses you might incur:

> Printing of releases to send to the media
>
> Creation of web page(s)
>
> Creation and blasting of an email
>
> Refreshments
>
> Hiring of a salesperson

Some income you might receive:

> Pre-exhibit income
>
> Sales during exhibit
>
> Sales after exhibit relating to event

Set a goal as to how much money you anticipate bringing in. Go over this with your salesman. Use this as initiative to make that one extra sale. Have some scripts ready: "If you buy a second piece, I can give you a 20 percent discount on the second."

PROJECTIONS

In the following example, the artist expects to sell at his show one small piece to a previous buyer, a larger piece to a new customer, some cards, and prints. It looks like he is also trying to entice three new patrons to support him with a monthly payment toward the purchase of an original.

FINANCIAL PROJECTIONS

Financial projections help you to see mentally what you need to accomplish physically. All profitable businesses use projections.

SAMPLE

PROECTIONS FROM BANK EXHIBIT

January 1, 2014 – March 30, 2014

Income

Bank exhibit	$ 1500
After sales	3000
Personal/past clients	500
Cards/prints	200
New patrons @ $100	300
Projected income	$5500

Expenses

Mailers/invites	$ 50
Reception	75
Salesman	800
Overhead	300
Printing of greeting cards	250
Projected expenses	$1475

Net projected income	$4025

NET PROJECTED INCOME

If you are not content with the outcome on a projection, then it's time to think of what you can do to make it higher—either lower your expenses or attempt for more sales. All this analysis helps motivate you to sell more work.

You can even get more specific and note which clients are potential for the sales you have projected. This could help your salesperson focus on the contacts he makes at your opening event.

This might look like a lot of income for one month, but this exhibitt took lots of hours of work—both marketing and creating—and several months of planning.

Chapter 5
Tax Issues

Annual tax preparation

Retirement issues

Medicare

Imagination is more important than knowledge.
A Einstein

ANNUAL TAX PREPARATION

Even if you hire an accountant at year-end to file your tax return, you still have to keep records during the year. Your tax accountant will use your year-to-date P&L Statement to create your tax return. If you decide to do your own tax return, the IRS does provide instruction brochures to help you. You will need to file:

Schedule C

Schedule SE

Form 4562

Form 8829

SCHEDULE C

You will use your end-of-the-year profit/loss statement when filling in Schedule C (see example on pages 59–60).

SCHEDULE SE

When you file your tax return each year as a self-employed artist, one of the several forms you fill out is Schedule SE (self-employment taxes). When you're employed, your employer withholds these taxes from your paycheck (he pays half, you pay half). When you're fortunate enough to be your own boss, you get to pay the entire amount—a whopping 15.3%! That's a big hunk each year.

To make it easier psychologically to pay this tax—known as FICA—try to think of it as an investment or savings. These taxes are put into a fund that eventually will give you retirement income. Indeed, if you live to be 62, it can become that. Whether you could've invested it more wisely is not a consideration at hand; it is an IRS requirement to pay these taxes. If you have extra funds beyond that, you can (if you are smart) invest them into a private retirement fund.

FORM 4562

You will use this form if you have any assets in your business that need to be depreciated.

FORM 8829

To establish a home-office deduction that meets the IRS requirements, you must be able to prove that your home office is used both *exclusively* and *regularly* for business purposes. That requirement is absolute and must be met by every taxpayer who takes the home-office deduction.

You paint at home, right? You market from your studio/office. This studio/office deduction will most likely apply to you. (Teachers, for instance, who teach at a school and then come home to use their office for an hour a day will not qualify.)

THE TAX MAN COMETH AGAIN

by Barbara A Sloan

The mere mention of the word "tax" has most of us running for shelter. Fortunately for artists, many shelters can be found nestled within that complex and cryptic diatribe known as the Tax Code. And all these tax breaks for artists are perfectly legal!

The importance of keeping good records

In the world of taxation, there is nothing more important than accurate bookkeeping. Not only does it make your tax preparation incredibly simple, but your books can show you where your money is coming from (which venture) and how you are spending, and, ultimately, what to change to become more profitable. Your records do not need to be kept in any particular format, but they must reflect your taxable activities. Should you have receipts for activities that are "ordinary and necessary" to your business, do not hesitate to use them as deductions. Keep in mind, however, this tax adage: Pigs get fat; hogs get slaughtered.

Income tax filing requirements

Not all income is taxable, but gross profits from sales, barters, and trades certainly are. If you are a hobbyist, your hobby income is subject to tax, and you will necessarily pay more in income tax than if you claimed your income and expenses as a business. If you are a sole proprietor earning more than $400 net profit within the year, you must file a Schedule C (Net Profit from Business) and Schedule SE (Self-Employment Tax) with your Form 1040 and perhaps include a Form 4562 (Depreciation) and Form 8829 (Business Use of Home).

Extensions and amended income tax returns

If you can't finish your return before April 15, file Form 4868 (before April 15) to get an automatic four-month extension. A second extension (Form 2688) for an additional two months requires approval from the IRS. Note that extensions only delay the filing deadlines, not the due dates for your tax payments. If you have underpaid your taxes, you could be subject to interest and penalties. Once you file your return, you can amend it by filing Form 1040X.

Beyond income taxes

Despite the focus on Federal income tax, there are other types of taxes for which you may be liable. There are Federal taxes on employment (for Social Security and Medicare), certain gifts, and some estates. Many state and local governments assess taxes not only on income but on sales and special types of property. There are even taxes on unemployment! Taxation has a tremendous function in American society, but it should never become the basis for your personal or business decisions. Use it wisely!

Barbara A Sloan is an award-winning artist who has been selling her work since 1968. She has worked on artists' taxes since 1979 and holds a Juris Doctorate in taxation. Her *QUICK-FIX TAXKITS*—easy-to-use tax kits for Schedule C, general taxes, and record keeping—are in their twelfth year of publication. Barbara can be contacted by email at info@akasii.com or at www.akasii.com. Phone consultations available.

If you anticipate making no more net profit (after expenses) than $2000–3000 annually on your art business, you probably do not have to pay quarterly estimated taxes.

Additionally, you must meet at least one of these three conditions:

1. Your home office is your principal place of business, or

2. Your home office is a place where you regularly meet with customers or clients, or

3. Your home office is a separate structure not attached to your home.

If you can prove one of the above, you can take a home-office deduction. Home-office deductions cannot exceed the net income from your art business. (Talk to your accountant about this.)

If you qualify for home-office deduction, you can deduct a:

- Percentage of the rent

- Percentage of heating, lights, air conditioning, cleaning

Alternatively, if you decide to rent a studio away from your home, 100 percent of those expenses can be deducted and you don't need to file Form 8829. Keep your rental contract and bank statements showing your rental payments.

AUTOMOBILE DEDUCTION

You should keep an auto log in your car to record your business mileage. If you get audited by the IRS and have deducted usage of your car (on Schedule C), you will need this log to validate your business mileage. You can calculate your business mileage deduction in one of two ways: by "actual mileage method" or by "per-mile method." The per-mile method is simpler to use. Each year the government sets a per-mile deduction rate; so many cents per mile. After you figure out the total business miles from your mileage log, you multiply the miles times the government-set per-mile rate to get your mileage deduction.

EDUCATION EXPENSES

You can deduct education expenses that further the possibilities of your income, such as a watercolor workshop, framing workshop, marketing seminar.

ESTIMATED TAXES

Once you decide to go into business, you will be self-employed. The IRS will then require that you pay your estimated annual tax liability one quarter at a time. They will send you the proper forms to fill out each quarter. Use your quarterly profit/loss statement to determine estimates of income for the year, and thus your quarterly tax payment.

Keep in mind: You can be employed and self-employed at the same time. If this is your case, you might not have to make quarterly estimated tax payments. Your employer is already taking taxes out of your paycheck. Consult with your accountant or the IRS to discuss your situation.

IS BEING AN ARTIST A BUSINESS?

By Peter Jason Riley, CPA

The first hurdle visual artists often have is the question regarding whether their "art" is indeed a business for tax purposes. The heart of this matter is whether the IRS sees the endeavor as a real "business" or as a "hobby." Because the artist's ventures often (sadly) yield losses, the question then becomes, "When does the tax code determine an enterprise to be a true business as opposed to a hobby." Here's how you may be affected by these so-called "hobby" rules.

Although you must claim the full amount of income you earn from your hobby, hobby-related expenses are generally deductible only to the extent of income produced by the activity: If you don't generate any income from your hobby, you can't claim any deductions. What's more, even those hobby expenses which can be deducted are subject to an additional limitation: they are considered miscellaneous itemized deductions on Schedule A, which are deductible only to the extent that they exceed two percent of your adjusted gross income. In contrast, if your activity can be classified as a bona fide business, you may be able to deduct the full amount of all your expenses by filing a Schedule C. In short, a hobby loss won't cut your overall tax bill because the tax law stipulates that you can't use a hobby loss to offset other types of income.

Converting your hobby into a bona fide business means you can deduct a net loss from other income you earn, such as wages and salaries. How does the IRS determine whether your activity is a hobby or a for-profit business? The Internal Revenue Service publications discuss these nine criteria:

1. Whether you carry on the activity in a businesslike manner.
2. Whether the time and effort you put into the activity indicate you intend to make it profitable.
3. Whether you are depending on income from the activity for your livelihood.
4. Whether your losses from the activity are due to circumstances beyond your control (or are normal in the start-up phase of your type of business).
5. Whether you change your methods of operation in an attempt to improve the profitability.
6. Whether you have the knowledge needed to carry on the activity as a successful business.
7. Whether you were successful in making a profit in similar activities in the past.
8. Whether the activity makes a profit in some years, and how much profit it makes.
9. Whether you can expect to make a future profit from the appreciation of the assets used in the activity.

The primary determinant is your ability to make a profit at what you are doing. If your efforts result in a profit in three out of five consecutive years, your activity is presumed not to be a hobby by the IRS. If you don't meet the three-out-of-five years profit rule, is all lost? Not necessarily, if you can prove to the IRS's satisfaction that you have made a genuine effort to earn a profit and that the reason you are not successful is related to special circumstances, the IRS might agree that your art is, in fact, a business. This is often true for individuals engaged in the arts, where profits and successes are difficult to achieve. To increase your chance of gaining the IRS's recognition of your business, I recommend that you run your activity in a professional, businesslike manner. Doing such things as having business cards and stationery, a web presence (with a sales component), maintaining a separate business checking account and telephone number, keeping accurate records of the time you put in, and carefully documenting all business-related expenses and activities. The IRS places great credence on computerized accounting records as evidence of the artist's "businesslike" intent. Keep records of all show entries (even including ones that you don't get into) and all gallery activity—any attempts related to selling your artwork.

Riley & Associates is located in Newburyport, MA. Peter Jason Riley is the author of *Tax Guide for Writers, Artists, Performers & Other Creative People*, now in its third edition. His web site—www.artstaxinfo.com—has many resources to help you with bookkeeping and taxes. For questions contact him at peter@cpa-services.com.

FORM 1099

If you receive more than $600 in any calendar year from a company or individual, you should expect to receive a Form 1099-Misc from them. Private purchasers of art probably do not know about this requirement, and therefore most likely will not send you one.

Likewise, if *you* pay someone over $600 in any calendar year for services rendered (work-for-hire, a printer, landlord, freelancer) you need to:

▸ Report this on Form 1099-Misc by January 30 of the following year to the person to whom you paid the funds.

▸ Send a summary report (Form 1096) to the IRS by February 28.

Forms 1096 and 1099 can be downloaded from www.irs.gov.

OTHER TAX ISSUES

Many artists worry about taking a loss for more than three years on their tax return from being a self-employed artist. Such cases have come before the courts. When an artist keeps in-depth and accurate records and is actually trying to create a business, his continuous losses are considered valid. For instance, if you studied art, sold some of your work, approached galleries for shows, kept a mailing list, had articles written about you, got a grant, taught art—all these validate that you are attempting to make a living at selling your art. Don't feel guilty about reporting a loss; you should see Bank of America's tax loss!

TAX WEB SITES

www.irs.ustreas.gov

www.HRBlock.com

www.legalartmiami.org

RECOMMENDED READING

You've Earned It, Don't Lose It by Suze Orman

SCHEDULE C
(Form 1040)

Department of the Treasury
Internal Revenue Service (99)

Profit or Loss From Business
(Sole Proprietorship)

▶ For information on Schedule C and its instructions, go to *www.irs.gov/schedulec*
▶ Attach to Form 1040, 1040NR, or 1041; partnerships generally must file Form 1065.

OMB No. 1545-0074

2011

Attachment
Sequence No. **09**

Name of proprietor

Social security number (SSN)

A Principal business or profession, including product or service (see instructions)

B Enter code from instructions
▶

C Business name. If no separate business name, leave blank.

D Employer ID number (EIN), (see instr.)

E Business address (including suite or room no.) ▶
City, town or post office, state, and ZIP code

F Accounting method: **(1)** ☐ Cash **(2)** ☐ Accrual **(3)** ☐ Other (specify) ▶

G Did you "materially participate" in the operation of this business during 2011? If "No," see instructions for limit on losses ☐ Yes ☐ No

H If you started or acquired this business during 2011, check here ▶ ☐

I Did you make any payments in 2011 that would require you to file Form(s) 1099? (see instructions) ☐ Yes ☐ No

J If "Yes," did you or will you file all required Forms 1099? ☐ Yes ☐ No

Part I Income

1a	Merchant card and third party payments. For 2011, enter -0-	**1a**	
b	Gross receipts or sales not entered on line 1a (see instructions)	**1b**	
c	Income reported to you on Form W-2 if the "Statutory Employee" box on that form was checked. **Caution.** See instr. before completing this line	**1c**	
d	**Total gross receipts.** Add lines 1a through 1c	**1d**	
2	Returns and allowances plus any other adjustments (see instructions)	**2**	
3	Subtract line 2 from line 1d	**3**	
4	Cost of goods sold (from line 42)	**4**	
5	**Gross profit.** Subtract line 4 from line 3	**5**	
6	Other income, including federal and state gasoline or fuel tax credit or refund (see instructions)	**6**	
7	**Gross income.** Add lines 5 and 6 ▶	**7**	

Part II Expenses Enter expenses for business use of your home only on line 30.

8	Advertising	**8**		**18**	Office expense (see instructions)	**18**	
9	Car and truck expenses (see instructions)	**9**		**19**	Pension and profit-sharing plans	**19**	
10	Commissions and fees	**10**		**20**	Rent or lease (see instructions):		
11	Contract labor (see instructions)	**11**		**a**	Vehicles, machinery, and equipment	**20a**	
12	Depletion	**12**		**b**	Other business property	**20b**	
13	Depreciation and section 179 expense deduction (not included in Part III) (see instructions)	**13**		**21**	Repairs and maintenance	**21**	
				22	Supplies (not included in Part III)	**22**	
				23	Taxes and licenses	**23**	
				24	Travel, meals, and entertainment:		
14	Employee benefit programs (other than on line 19)	**14**		**a**	Travel	**24a**	
15	Insurance (other than health)	**15**		**b**	Deductible meals and entertainment (see instructions)	**24b**	
16	Interest:			**25**	Utilities	**25**	
a	Mortgage (paid to banks, etc.)	**16a**		**26**	Wages (less employment credits)	**26**	
b	Other	**16b**		**27a**	Other expenses (from line 48)	**27a**	
17	Legal and professional services	**17**		**b**	**Reserved for future use**	**27b**	

28	**Total expenses** before expenses for business use of home. Add lines 8 through 27a ▶	**28**	
29	Tentative profit or (loss). Subtract line 28 from line 7	**29**	
30	Expenses for business use of your home. Attach **Form 8829.** Do **not** report such expenses elsewhere	**30**	
31	**Net profit or (loss).** Subtract line 30 from line 29. • If a profit, enter on both **Form 1040, line 12** (or **Form 1040NR, line 13**) and on **Schedule SE, line 2.** If you entered an amount on line 1c, see instr. Estates and trusts, enter on **Form 1041, line 3.** • If a loss, you **must** go to line 32.	**31**	
32	If you have a loss, check the box that describes your investment in this activity (see instructions). • If you checked 32a, enter the loss on both **Form 1040, line 12,** (or **Form 1040NR, line 13**) and on **Schedule SE, line 2.** If you entered an amount on line 1c, see the instructions for line 31. Estates and trusts, enter on **Form 1041, line 3.** • If you checked 32b, you **must** attach **Form 6198.** Your loss may be limited.	**32a** ☐ All investment is at risk. **32b** ☐ Some investment is not at risk.	

For Paperwork Reduction Act Notice, see your tax return instructions. Cat. No. 11334P Schedule C (Form 1040) 2011

Part III **Cost of Goods Sold** (see instructions)

Page **2**

33 Method(s) used to
value closing inventory: a ☐ Cost b ☐ Lower of cost or market c ☐ Other (attach explanation)

34 Was there any change in determining quantities, costs, or valuations between opening and closing inventory?
If "Yes," attach explanation . ☐ Yes ☐ No

35 Inventory at beginning of year. If different from last year's closing inventory, attach explanation . . .	**35**	
36 Purchases less cost of items withdrawn for personal use	**36**	
37 Cost of labor. Do not include any amounts paid to yourself	**37**	
38 Materials and supplies	**38**	
39 Other costs	**39**	
40 Add lines 35 through 39	**40**	
41 Inventory at end of year	**41**	
42 **Cost of goods sold.** Subtract line 41 from line 40. Enter the result here and on line 4	**42**	

Part IV **Information on Your Vehicle.** Complete this part **only** if you are claiming car or truck expenses on line 9 and are not required to file Form 4562 for this business. See the instructions for line 13 to find out if you must file Form 4562.

43 When did you place your vehicle in service for business purposes? (month, day, year) ▶ / /

44 Of the total number of miles you drove your vehicle during 2011, enter the number of miles you used your vehicle for:

a Business _____ b Commuting (see instructions) _____ c Other _____

45 Was your vehicle available for personal use during off-duty hours? ☐ Yes ☐ No

46 Do you (or your spouse) have another vehicle available for personal use? ☐ Yes ☐ No

47a Do you have evidence to support your deduction? ☐ Yes ☐ No

b If "Yes," is the evidence written? . ☐ Yes ☐ No

Part V **Other Expenses.** List below business expenses not included on lines 8–26 or line 30.

48 **Total other expenses.** Enter here and on line 27a	**48**

Schedule C (Form 1040) 2011

Each person's retirement situation varies. You will need to do your own research so you can be on top of your personal retirement situation.

As the brochures received from the Social Security Administration indicate clearly to the reader, "Social Security is not intended to meet all your financial needs." Many people have retirement options with their employment, but as a self-employed artist you'll need to look into any additional retirement packages on your own—IRA, Roth IRA, and more.

WHAT DO I HAVE COMING IN THE FUTURE?

To receive Social Security benefits when you retire (or become disabled), you must have worked at least ten years and made $2560+ each of those years (at today's rate). The more you earn, the more monetary benefits you will qualify for. Basically, you will receive about 42% of your average earnings.

It is possible to find out what your estimated income will be at retirement. Call 800/772-1213 or go online to www.ssa.gov/mystatement to ask for a Request for Earnings and Benefit Estimate Statement. About one month after you return the form to the IRS, you will receive your complete earnings history, along with estimates of your benefits for early retirement (62), full retirement (65), and age 70 retirement. You will also receive disability benefit estimates, and the amount payable to spouse and children should you die or become disabled.

SOME THINGS TO KEEP IN MIND

- ▸ Higher lifetime earnings may result in higher benefits when you retire.

- ▸ You can earn money as well as receive social security benefits. Part of these earnings might be taxable, however. If you earn over an allotted amount, your retirement benefits could also be lowered.

- ▸ If you have another pension plan, the amount of your Social Security benefits may be reduced.

- ▸ A spouse can receive up to 50 percent of a mate's benefits, even if divorced and in some cases remarried, even if the ex-mate is not presently eligible to receive benefits. You must have been married at least ten years in order to qualify. Having a mate receive benefits on your record won't affect your own benefits.

- ▸ If poor health makes you retire early, you can apply for Social Security disability benefits. The amount of the disability benefit is the same as a full, unreduced retirement benefit.

When preparing for your retirement, you should talk to a Social Security representative the year *before* you plan to retire. Rules are complicated, and you will be able to find out what plan is best for your personal circumstances.

RETIREMENT ISSUES

A private retirement account started early in life, even if only $500 a year, is a must in our present economic outlook. Taking charge of your financial future is empowering and stress relieving. Be careful where you invest your retirement funds. If it sounds too good to be true (a 20% annual return), then it most likely is!

MEDICARE

www.medicare.gov

MEDICARE PART A - HOSPITAL INSURANCE

If you qualify for Social Security benefits, you automatically qualify for Medicare Part A (at age 65) benefits at no charge—or you may qualify on a spouse's records. If you *don't* qualify for Social Security coverage, you can (at age 65) pay for Part A. Part A hospital insurance helps pay for inpatient hospital care, skilled nursing facility care, home health care, and hospice care.

MEDICARE PART B - MEDICAL INSURANCE

Part B is an optional health program that costs additional per month. Medicare Part B helps pay for doctors' services, outpatient hospital services, home health visits, diagnostic X-rays, laboratory and other tests, ambulance services, medical services and supplies.

Chapter 6
Legalities

Copyright

Legal rights

Estate planning

Contracts

Checklist for contracts

Resources

No! No! Sentence first, verdict afterwards.
Through the Looking Glass, Lewis Carroll

COPYRIGHT

The sale of your artwork does not give buyers the ownership of copyright. If they want this additional benefit, they must have your written agreement. You should never, however, give up your copyright unless you are being paid very well. It is the most valuable asset for your business and for you as an artist.

Any new business must investigate legal rights related to their particular venue; an artist is no exception. If you know your legal rights, you will be a wiser negotiator and a better businessperson. If you know these rights from the start, chances are you will not be taken advantage of by anyone.

This chapter cannot possibly cover all the details you will need to know but it will inform you about some of the basics of which you should be aware (a list of publishers of art-related legal books can be found on page 74).

COPYRIGHT REGISTRATION

Since 1978, you are not required to put the copyright © symbol on your work to protect it. You still have to prove it is your original creation, however. So how do you do that? You file copyright with the Copyright Office in Washington, DC. Formal copyright registration can now be done online digitally at www.copyright.gov or www.copyrightregistry-gov-form.us. When you register with the copyright office in Washington, DC, you become eligible to receive statutory damages and attorney's fees in case of an infringement suit.

To be copyrightable, a work must be both original and creative; it must be a physical expression of an idea. It may be a logo, illustration, fine artwork, oil painting, transparency, photograph, chart, diagram, video, filmstrip, motion picture, slide show, computer software program, typeface.

COPYRIGHT LAW OF 1976

Under the copyright law of 1976, any work created on or after January 1, 1978, is protected by common-law copyright as soon as it is completed in some tangible form. As the creator, you have certain inherent rights over your artwork, including the ability to control how it is used.

▸ You have the exclusive right to reproduce, sell, distribute, and display your artwork publicly. This protection lasts until 50 years after an artist's death. It can be renewed by an artist's heir(s).

▸ You also have the right to transfer the copyright to heirs in your will.

▸ You can transfer part or all of your copyright through a sale, gift, donation, or trade. You must do this in writing. This is not the same as selling or transferring ownership of an artwork. You can sell a first-reproduction right to one company, say for greeting cards, and a second-reproduction right to another, say for a calendar, as long as each contract allows you to do that.

COPYRIGHT INFRINGEMENT

Infringement occurs when someone derives a work of art directly from a work by someone else. If you derive a painting from a photograph clipped from a magazine,

for example, you might be infringing. With computer-generated art, this has become an increasing concern. If you copy from an existing image, you need to alter your work to the extent that a casual observer would not notice a resemblance.

PASSING YOUR COPYRIGHT ON TO YOUR HEIRS

To pass the copyright of your artwork on to your heirs, you must have an Assignment of Rights in writing and signed by all parties to make this legal. It's also a good idea to record this Assignment of Rights with the Copyright Office. Doing so will make it a matter of public record. Anyone then searching for the copyright status of a work would learn that a particular person now controls the copyright.

SOME LAWS TO CONSIDER

▸ Under California law, any gallery, representative, or owner who sells a work of art must inform the artist, upon request, of the name and address of the new owner. Did you know that? Some galleries don't even know this; and some that do know of it don't abide by it.

▸ California has also enacted a law to help protect artists when their work is resold—Resale Royalties Act. It enables artists to continue receiving a share of royalties of sales when their artwork is passed from one collector to another. For an emerging artist, this might not mean much. When you become known and your works are being auctioned and sold at higher and higher prices, you will appreciate this law!

▸ Under federal law, the artist must be given proper credit when his work is exhibited or displayed.

▸ Only artists who can prove tribal membership can be advertised as Indian or Native American. Fines may be as high as $250,000 for the dealer or artist who does not comply with this regulation.

▸ You can sell rights—they are not usually "lifetime" or "complete"—to a copyrightable piece without selling the original. Each type of right of usage will require a separate legal agreement.

▸ Did you know that when you hire a photographer to take pictures of your artwork, the photos are his copyrightable images? You will need to get in writing that he agrees to relinquish this right.

▸ If your painting of a publicly known person or a public building is used to inform and educate the public, then you won't need a model release. The only exception is if the painting depicts something that could be embarrassing to someone. If the painting is used for promotion, endorsement, advertising, or other commercial or trade use, you will need a model or building release.

An international copyright that will automatically protect an artist's works throughout the world does not presently exist. Protection against unauthorized use in a particular country depends on the country's laws.

LEGAL RIGHTS

CERTIFICATE OF AUTHENTICITY

Most states have statutes requiring dealers to provide a certificate of authenticity or a similar document disclosing pertinent facts about multiple editions. This certificate must be given before or at the time of the sale. This disclosure must also appear in promotional materials regarding limited editions. Failure to provide a certificate or to disclose information properly entitles the buyer to rescind the transaction and receive his money back with interest. An artist who sells his works directly is considered a dealer.

CERTIFICATE OF AUTHENTICITY

This certificate guarantees that this print, number _____ of a limited edition of _____ prints, is personally signed and numbered by the artist.

ARTIST _____

ADDRESS _____

TITLE _____

MEDIUM _____

DIMENSIONS _____

YEAR PRINTED _____

SIGNATURE OF ARTIST _____

DATE OF SALE _____

WORK-FOR-HIRE

Work-for-hire occupies a special category under copyright law. If you are employed or apprenticed and you create a work of art through the scope of your employment or apprenticeship, your employer owns the copyright to your work; that is, the copyright owner is the person who does the hiring. The creator has no rights to the work whatsoever, unless she and the employer have agreed in advance to the contrary. Any such agreement must be written and signed by both parties. View a work-for-hire agreement at www.artmarketing.com/workforhireagreement.pdf.

COMMISSIONED WORKS

A commissionable work is not considered a work-for-hire since you are not employed. In almost all cases, the creator of a commissioned work owns the copyright, not the person who commissioned it. Only certain types of commissioned work are treated as works-for-hire. Be careful here. Artists confronted with "work-for-hire" imprinted on the back of checks received from patrons should cross out the wordage to fight the attempted rights takeover.

WORK AGREEMENT

Agreement made this _____ day of _____ 20___, between _____ _____ (hereinafter "Company") and _____ (hereinafter "Artist") for the preparation of _____ artwork(s) for the _____ (hereinafter "Project").

1. Artist shall submit the artworks in finished form no later than _____.

2. Company will pay Artist the sum of $_____ for each artwork, to be paid one quarter upon signing of this agreement, one quarter upon delivery of preliminary studies, and one half upon delivery of the finished artwork.

3. Any and all artwork created pursuant to this agreement shall remain in the possession of the Artist, including copyright to the work, for any and all purposes throughout the world, except for the specific purpose contained herein.

4. Artist represents and warrants that he/she is the creator of the artwork specified herein, that it does not infringe on any rights of copyright or personal rights and rights of privacy of any person or entity and that any necessary permissions have been obtained.

5. Artist agrees that he/she is working as an independent, free-lance contractor and will be responsible for payment of all expenses incurred in his/her preparation of said artwork.

IN WITNESS WHEREOF, the parties hereto have duly executed the agreement the day and year first above written.

ARTIST _____ DATE _____

COMPANY _____ DATE _____

ESTATE PLANNING

If you plan correctly, your artwork can survive after your death. Should you become ill, or be at the age where you feel comfortable with estate planning, here are some pointers. If you have not done your homework throughout the years, it will be much more difficult to get the necessary records in order.

▸ Your work needs to be organized, documented, and inventoried.

▸ You will need to decide, if the works are in your possession when you die, who will be responsible for finding a good home for them. Don't name any persons, public facility, or company as a recipient of your work unless you have talked to them first.

▸ Hospitals and libraries are two public institutions that would benefit from donated artwork. You don't want your art stored. It does nobody good in storage.

▸ You need to prepare a will that indicates your desires. Be sure to note in the will who will own the copyrights. It is best to pass the copyright ownership along with the artwork; otherwise heirs might owe more taxes than they planned.

There are two types of contracts you can use in your business. When dealing with another art professional—a gallery, consultant, museum curator, publisher—you need to have a formal contract. When dealing with a private collector, you can have a "user-friendly" contract.

FORMAL CONTRACT

Art professionals will often have a standard contract that they want an artist to sign. If you find yourself in this position, take time to look it over carefully. Make sure you ask them about anything you do not understand or anything you disagree with. Do this in writing so you have a record of what you asked and what they answered (an email will suffice). If you don't like their answer, then propose an alternative approach. If that doesn't get approved, then another compromise will have to be made. Both parties must be content upon signing. Do not give up rights that you shouldn't, but don't get stuck on small details either.

USER-FRIENDLY AGREEMENTS

A user-friendly agreement is a letter or form, often on business letterhead, that states in simple terms the rights of the artist. In a user-friendly agreement you would want to include this information:

▸ Rights of reproduction

▸ Right to photograph

▸ Right to reacquire the work for a retrospective

▸ Royalty on sale of artwork

▸ Share of rental income

▸ Any limitation regarding exhibition of artwork

TIP

→ Whenever you send an agreement through the mail, register it with a return receipt attached. You will then have a record that it was received.

MEDIATION CLAUSE

Most of the Volunteer Lawyers for the Arts (see page 74) have an arts arbitration and mediation service that uses a panel of artists, attorneys, and arts administrators to conduct hearings and resolve disputes, saving time on trial costs.

It is important in any contract you sign, therefore, to have a mediation clause. Since you do not want to go to court, nor do you want to lose a painting or have

CONTRACTS

If a gallery says they don't sign contracts with artists, run out of there like a rabbit. Don't have anything to do with them.

BILL OF SALE

Sold to _____

Address _____

Phone _____

DESCRIPTION OF WORK

Title _____

Date completed _____ Size _____

Medium _____ Framing _____

Miscellaneous _____

TERMS OF SALE

Purchase price _____ Sales tax _____

Shipping _____ Total _____

Cash/check _____ Credit card _____

→ Resale or transfer of work requires that artist be informed of the new owner and the price of sale. Should the price be more than $1000 over the original price stated herein, according to California state law, 10% of amount over original price shall be given to artist by seller.

→ Artist shall have right to photograph piece, if necessary, for publicity or reproduction purposes.

→ Artist shall have right to include artwork in retrospective show for a maximum of 3 months.

→ If artwork is rented out by purchaser, artist will receive 25% of rental income.

→ Artwork cannot be exhibited in public without written approval of artist.

ARTIST'S SIGNATURE _____ DATE_____

ADDRESS _____ PHONE _____

RECEIVED IN GOOD CONDITION:

PURCHASER'S SIGNATURE _____ DATE_____

ADDRESS _____ PHONE _____

REPRODUCTION RIGHTS RESERVED BY ARTIST

it returned to you damaged, a mediation clause will give you more power. In mediation, the two parties are brought together to resolve differences; each party must give and take a bit.

HIRING A LAWYER

As an artist with a legal question, you don't want to hire a lawyer who specializes in real estate or accident law. Be sure to hire the correct genre of lawyer. If you are working on a licensing or royalty agreement, you want an "intellectual property attorney" who specializes in copyright and publishing law.

When you interview a potential lawyer, be sure to understand the pricing structure: How much will you be charged for speaking for five minutes on the phone with them? It's a good idea to evaluate your lawyer's credentials. See what cases she has worked on that might be similar to yours.

CHECKLIST FOR CONTRACTS

See a sample gallery contract at www.artmarketing.com/gallery contract.pdf.

❑ Parties involved.

Gallery: Continuity of personnel, location. Assignability.

Artist: Extension to spouse, children. Estate.

❑ Duration. Fixed term, contingent on sales/productivity. Options to extend term. Different treatment of sales at beginning and end of term.

❑ Scope. Media covered. Past and future work. Gallery's right to visit the studio. Commissions. Exclusivity. Territory, studio sales, barters or exchanges, charitable gifts.

❑ Shipping. Who pays to/from gallery. Carriers. Crating.

❑ Storage. Location, access by artist.

❑ Insurance. What's protected in-transit/on-location.

❑ Framing. Who pays for framing; treatment of expense on works sold.

❑ Photographs. Who pays, amount required (B&W and color), ownership of negatives/transparencies, control of films.

❑ Artistic control. Permission for book/magazine reproduction. Inclusion in gallery group exhibits. Inclusion in other group exhibits. Artist's veto over purchasers.

❑ Gallery exhibitions. Dates. Choice of works to be shown. Control over installation. Advertising. Catalog. Opening. Announcements/mailings.

❑ Reproduction rights. Control prior to sale of work. Retention on transfer or sale of work. Copyrights.

❑ Damage/deterioration. Choice of restorer. Expense/compensation to artist. Treatment for partial/total loss.

❑ Protection of the market. Right of gallery to sell at auction. Protection of works at auction.

❑ Selling prices. Initial scale. Periodic review. Permission if discounts are offered. Negotiation of commissioned works. Right to rent versus sell.

❑ Billing and terms of sale. Extended payment, credit risk, allocation of monies as received, division of interest charges, qualified installment sale for tax purposes. Exchanges/trading up. Returns.

❑ Compensation of the gallery. Right to purchase for its own account.

❑ Income from other sales. Rentals. Lectures. Prizes/awards. Reproduction rights.

❑ Accounting/payment. Periodicity. Right to inspect financial records. Currency to be used.

❑ Advances/guarantees. Time of payment. Amounts and intervals. Application to sales.

❑ Miscellaneous. Confidentiality of artist's personal mailing list. Resale agreements with purchasers. Right of gallery to use artist's name and image for promotional purposes.

❑ General provisions. Representations and warranties. Applicable law. Arbitration.

RESOURCES

VOLUNTEER LAWYERS FOR THE ARTS

www.vlany.org 212/319-2787

This organization, with branches in New York, San Francisco, and Santa Monica, provides artists and art-related businesses with legal assistance—sometimes free, sometimes for a nominal fee. Informative newsletters and excellent books about legal issues are published by some branches, as well as conducting seminars and classes related to legal rights for artists.

ALLWORTH PRESS

www.allworth.com

Legal guides and other books for visual artists

LEGAL INFO

www.dubofflaw.com

Books for artists, seminars on tape and video

SELF-HELP LAW CENTER

www.nolo.com

Many books on a variety of legal topics

Chapter 7
Pricing Your Artwork

Pricing methods

Signing and titling art

A fool and his money are soon parted.
Anonymous

PRICING METHODS

As a potential buyer, I might think something is wrong with a piece, or won't value it much, if the listed price is below what I personally feel is its fair market value.

When you consider the aspect of pricing your work, think "price range," not just one price. Determine price range, and then price according to size, subject, media, framing, and importance of work. You'll have to do some research in order to find out what this price range should be for your work.

TIME AND OVERHEAD PRICING

In order to survive, most working artists will need to be able to complete at least four originals a month. This doesn't mean you will sell all four pieces each month, but you need to build a stock so your clients have a variety of work to choose from. If it takes you a month of working eight hours a day to finish one painting, this probably means you will have to get involved in the print market. (See *Licensing Art 101* available at www.artmarketing.com.)

To calculate time and overhead pricing:

1. Project total business expenses for the year (dues, education, utilities, publications, postage) to figure the per-month overhead. For instance, $6000 per year divided by 12 months equals $500 per-month business expenses.

2. How many pieces do you complete in a month on the average? 4

3. Divide the monthly overhead by the number of pieces: $125 ($500 ÷ 4 pieces)

4. Decide on an hourly rate of pay for yourself: $25

5. How many hours to complete an average painting? $25x25=$625

6. Add a 10% profit margin on labor and overhead: $75.00

7. Add a 100% commission (that's for the salesperson (you, a rep, a gallery).

 $125 overhead cost

 $625 labor

 $750 subtotal

 $ 75 profit margin

 $825 subtotal

 $825 commission at 100%

 $1650 retail price on unframed 24x36″ work

This $1650 price is not cut in steel. It's an aid to help you see the general price range of the work.

If you personally do the framing, the frame price would include your material and labor costs, but no markup. If you have a framer prepare the frame, charge the cost plus an hourly wage for your time spent on the process (maybe two hours at most).

PRICING WORKSHEET FOR ORIGINALS

Title of work _____ Code # _____

Date started _____ Date completed _____ Total hours _____ Hourly rate _____ Salary _____

Materials used in execution of piece (brand name of materials, type of paint, paper, fiber, metals) _____

Cost $ _____

Materials used in presentation (base, backing, frame, mat, protective covering, hanging rods) _____

Cost $ _____

Overhead	A	$	
Salary (hourly rate x total hours)	B	$	
Profit (10% of above two items)	C	$	
Subtotal (A + B + C)	D	$	
Commission (equal to D)	E	$	
Retail price (unframed) (D + E)	F	$	
Frame, mat	G	$	
Retail price/framed (F + G)	H	$	

Gradual increases in price is the way to go. Collectors like to see a little movement in an artist's prices over the years. If the market softens, you won't find your prices out of line.

Usually you are not trying to make a profit on the framing, just the artwork (but you do want your material and labor paid for!).

Eventually you will add the local tax and shipping costs (if need be).

MARKET-VALUE PRICING

Another method used to calculate a price range is to figure out what other artists with the same type of background and similar art are selling their artwork for. (Do verify that these artists are selling—not just exhibiting. Maybe they are charging too much and not selling a thing.)

PERCEIVED-VALUE PRICING

When you have a show, you'll discover that pricing an artwork at either $175 or $225 will often get the same sales results. You might see that if someone can pay $100, they most likely will be able to pay $150–175 but not $200. Products or services are bought on the basis of perceived value in the minds of buyers and not on the basis of what it costs you to produce. To study perceived value, you need to be on-site at your exhibit. Study how people are reacting, what they're saying about your work and prices. What are they buying?

BY-THE-SQUARE-INCH PRICING

Use calculations from the previous two methods to figure out what your price per square inch is. The example on the previous page comes out to approximately $2 per square inch. So if you create a 36x48″ piece, it would be priced at $3450.

TO COMPARE

Once you make the calculation, you will have to compare it to market-value pricing. If there is a vast difference, you may not be able to make any sales using this price base.

Where do you go to compare? You don't go to the most expensive gallery in Beverly Hills. You go to juried shows, outdoor fairs, smaller galleries, and open studios in your area. When comparing pricing, keep in mind the aesthetic and technical merits of work, the style, medium, and reputation of the artist and intrinsic cost of product.

After you have done some research and calculations, consider the following:

▸ From your research, does the time-and-overhead price of $1650 seem to be in the appropriate range?

▸ If you are selling through a dealer and make $825 (50%) will you be able to make it financially? How many pieces will you need to sell per month?

It's generally a mistake to base your prices solely on the number of hours spent creating a work. It's good to know, however, if the time you spend creating and the prices you are charging make it possible for you to earn a decent living. Perhaps you cannot earn $25 per hour when you start. If that rate were lowered to $20 per hour, the price of the piece would drop to $1375. Is this closer to your perceived market value? This is the type of thinking and research you need to do before you set your price.

It's amazing how often artists forget to include the cost of their labor in a project. If you don't fully recoup your labor and outside costs, you are basically subsidizing collectors. Why would you want to do that? In dire times a sacrifice might be necessary, but to make it a daily practice is downright stupid.

PRICING MISTAKES

▸ Do not raise prices 100 percent in one year. (Only oil companies can get away with that!) Try instead to consistently raise your prices about 10 percent per year. Your previous clients will be happy, and your new clients will not notice.

▸ Do not put ridiculous prices on your pieces: $10,000 is too much if you've never sold anything before and too much if you've been selling in the $1500 range. If you want to exhibit a piece but don't want to sell it, note NFS (Not For Sale) on it. You can put one or two of your pieces in an exhibit at a higher price than the others: if your average price is $1500, you could price your favorite piece at $2500–3500. People will want to know why this one is higher. Be ready with a good story and you might make a sale.

▸ If you're going to create giclée prints, you need to make sure the prices are not too high relative to your originals. For instance, for an original 24x36″ acrylic piece selling for $1650, a giclée reproduced at 16x16″ should be no more than $160. If it is reproduced at the original size of 32x32″, perhaps the price could be raised to $200–225.

PRICING TIPS

→ People expect a small work to be priced lower than a large one. Though this might not make sense to the artist—miniatures are more time consuming to produce than large pieces—this is the psychology of the general public. If you don't think you can price smaller pieces for less, create large pieces.

→ The price that you charge from your studio and the price your dealer sells for must be the same. (You get to keep the commission when you sell a piece from your studio if there is no conflict of interest with your gallery.) Some collectors mistakenly expect your studio price to be 50 percent lower than a galleries price, but it should never be.

Before long, an artist who keeps labor records on each piece can learn to estimate quite accurately the approximate number of hours needed to produce any given work. This information can be useful when scheduling projects, budgeting, and pricing commissions.

Your goal is to set a price that strikes the consumer as fair, at the same time enticing him to buy.

→ Develop a long-term strategy connected with the pricing of your artwork. As you sell more, your prices will, of course, rise. As your prices increase, have smaller works or prints available in the lower price range.

→ Keep your work affordable to all your previous clients.

→ Studio inventory should always be at least ten pieces. If you only have four pieces in stock, it might be because you're selling at too low a price.

→ Always note the retail price on your price list.

→ Don't undersell your work. You must feel comfortable with the prices you decide on; otherwise, you will feel resentful.

→ Never prepare a proposal or model of a piece for anyone unless you are being paid. This is customary for architects and interior designers, and, as an artist, you need to make it customary too. Clients will respect you more if you do this.

→ Your clients should know that the price on the tag does not include sales tax, packing, and shipping. If the frame is not included, you need to make your customers aware of that as well.

→ Know your prices. When you have studied the market and know the various factors involved in pricing a product, you will have more confidence when someone questions a price.

→ Build an inventory of work in your most popular sizes and prices.

→ Try pricing with odd numbers—$372.46 or $1766.29. This can evoke curiosity and conversation about the price.

A gallery owner wanted a lower price on a work by an artist I was representing. Since it was a rather-simple-looking piece, he thought he could get me to come down on the price by asking me how long it took the artist to paint it. It was my favorite piece and the artist's first in a series, as well as the best of the series. I answered the gallery owner, "It took the artist 60 years to paint." That was true. The artist was 60 years old, and until he painted that particular piece, he could paint none like it.

DISCOUNT POLICY

Did you know that it is illegal to sell to one customer at a lower price than another customer on the same product? The Robinson-Patman Federal Act is designed to prevent unfair price discrimination. There are ways around this policy, however.

- Discount when purchasing a second piece.

- Discount with cash in hand, usually 2–5 percent. In all other cases—check, credit card, money order—the full retail price is paid. It is also illegal to charge more, or add a service charge, if someone uses a credit card. Alternatively, it is okay to charge less for using cash!

THE GOLDEN RULE

Don't sell anything that you wouldn't want to be known for in the future. It might reach the wrong hands and bring you bad publicity. Be proud of every piece you sell.

You need to have a reason for sale prices to be lower, but don't give the idea of selling something inferior, old, not wanted. Instead of a "Sale," have a "Special Buy."

SIGNING AND TITLING ART

SIGNING WORK

Your signature can become your "trademark" and validate the authenticity of your piece. A signature is important to collectors, sometimes even critical. When you become collectible, your signature will make it easier to decipher forgeries. You can sign a piece on the front or back—it's up to you, but be consistent with whichever way you choose. Some artists sign both front and back and even put the dimensions on the back (along with title and date), so further discrepancies might not occur.

Question: I have been an artist since I was 14 years old. All my paintings are signed with my maiden name. A colleague has questioned my signature on my recent paintings because I continue to sign my paintings with my maiden name, though I have begun to add the first initial of my married name at the end. I explained this to my colleague and she actually didn't believe that the paintings were mine! What should I do?

Answer: Continue to sign your name only with your maiden name, the way you started signing at the beginning of your career. Don't ever change your artist name or signature! It's too confusing. I would personally go back and paint out the extra initial on any painting.

TITLING WORK

There are several reasons to give your work a title:

▸ For cataloging purposes; if you do several versions of a dog or cat, you might need to number or title them

▸ To give the viewer a particular intellectual or emotional connection

▸ To give a clue to some subtlety or inspiration; perhaps telling where the piece was created or why it was created

▸ People remember titles

DATING YOUR WORK

Do not put a date of completion directly on your artwork; keep track of it on your historical worksheet for the piece, however. You don't want to advertise the fact that an artwork is seven years old; potential buyers might look upon an older piece as unsold and unwanted, not as a classic from your collection.

Chapter 8
Shipping Art

Packaging art

Shippers

We must never forget that art is not a form of propaganda;
it is a form of truth. John F Kennedy

PACKAGING ART

As your career expands geographically, you will need to learn more about proper packaging and shipping of artwork to protect it fully when you get an order from a distant client.

PACKAGING TIPS

▸ When unframed graphic work is shipped, be sure to mark it clearly. Works on paper could be mistaken for packing materials and be discarded.

▸ Flat prints should be placed on a foam board and shrink-wrapped. Package the foam board in heavy cardboard so nothing can puncture the piece.

▸ Mark the exterior of the box, "Fine Art," "Fragile," "Handle with Care," or "Glass."

▸ Mark clearly on the inside of the box the name of the gallery and the particular show at which your piece is being exhibited. Sometimes more than one show is occurring (or an agent is handling more than one show), and things get mixed up. The date of the show can also help.

▸ Put a small label on the back of your artwork with the title of your piece and your name, address, and phone number in case it gets separated.

▸ Include instructions for return shipping.

▸ If you package more than one piece in a carton, put them back-to-back or face-to-face with a piece of corrugated cardboard placed between. When taking them in a car or carrying them in a box, remember that screw eyes and other protruding objects on one piece may damage the other. Pad securely between the two items.

MATERIALS FOR PACKAGING AND CRATING

These companies carry a variety of packaging supplies that you can order online.

Airfloat Systems
www.airfloatsys.com
Double- or single-wall, corrugated, lightweight cardboard boxes in various sizes, lined with three layers of polyurethane on the inside. Foam suspends the art in the box, providing protection. Reusable boxes. Less expensive than a wooden crate.

MasterPak
www.masterpak-usa.com
Offers archival materials for packing, shipping, storing, and displaying fine art.

Pro-Pak Professional Shippers

www.propakinc.com

Art Carton Series is a product made of double-wall corrugated cardboard that protects fragile framed and glass-covered artwork. Comes in a variety of sizes. Custom designs can be ordered. Can be reused many times.

RT Innovations

www.portfolios-and-art-cases.com

Port—a convenient way to carry your artwork—is a line of expandable portfolios and oversized carrying cases.

SHRINK-WRAP

FedEx Office should be able to shrink-wrap flat prints for a nominal fee. If you will be doing a lot of wrapping, however, you might consider purchasing a shrink-wrap system. It is small enough to set up on a desk. It comes with a heat blower to shrink the plastic wrap tightly around any product.

Clearmount Corp

www.clearmountcorp.com

The Wand shrink-wrap system gives you the most flexibility and efficiency to shrink-wrap any size and shape of artwork. Uses an ultra-clear film.

Pictureframe Products

www.pictureframeproducts.com

Mini shrink-wrapper

MAILING TUBES

You can roll prints, watercolors, and even some oil and acrylic paintings for shipment into tubes made of heavy cardboard, plastic, or metal. Purchase at art supply stores.

CRATING

Proper crating is crucial to protect artwork from damage. Most shippers recommend the use of wooden crates rather than cardboard. Most carriers discourage shipping glass-framed artwork. You can remove the glass and have a new piece installed for much less than it would cost to insure it.

All work should be wrapped in plastic sheeting to prevent water damage. Framed works should be further protected; rolled-up newspapers are a good way to protect the corners. The ends of the rolled paper should be stapled to the back of the frame.

GLASS

When shipping framed, glassed artworks, it is important to tape the glass so that, in the event of breakage, it does not damage the work. Masking tape is strong enough to prevent pieces of glass from coming loose. Never use tape requiring water, as it could damage the work. Use easy-to-remove tape.

First tape a large ✕ on the glass. Then tape horizontal and vertical rows a couple of inches apart. Do not overlap the frame. Works covered with Plexiglas need no tape because it is break resistant.

Be sure you make it clear to your clients that it is their responsibility to pay for shipping and handling. Know the approximate cost to package and ship a piece, and offer that information to your client at the time of purchase if they do not live nearby.

Whenever you ship a piece consider:

- ▸ Timing: start early so you don't have to pay an overnight rate
- ▸ Rates: compare carriers
- ▸ Insurance: be aware of what coverage you are receiving
- ▸ Weight
- ▸ Size
- ▸ Does the shipper also package or pick up?

INSURANCE

No carrier treats packages gently. Insure all goods to the maximum value of your retail price. Various carriers set different maximums for the insured value. The process of reimbursement can be difficult. If a carrier finds that the artwork was extremely fragile or was not packed carefully, the insurance company may reject the claim. The artist must prove the value of his piece by providing sales receipts for objects of similar size or materials.

TIPS

- → If you can, place paintings upright instead of stacking them on top of each other. If you must stack the paintings, you need to separate them with something that will not damage them. This material must be as large as the largest painting it is touching and stiff enough to support it. Stack the largest piece on the bottom and work towards the smallest. If one or two small paintings are shipped along with large works, it is important to put the larger works in first and cushion them along the sides with strips of cardboard. Smaller works should be laid next to one another and stacked evenly. It may be necessary to provide compartments for small pictures.

- → When transporting glass by car, you will need blankets for protection. Take the time to do this. Wouldn't you hate to ruin a painting because some glass has broken and torn the paper or canvas?

- → Plan the arrival of your artwork about two weeks before any deadline or show. If problems arise, there will be time to take care of a repair or search for a lost package.

SHIPPERS

After exploring a few shippers—USPS, FedEx, UPS—you will discover which one is right for your needs.

Some artists offer free installation and delivery within a 25-mile radius of their studio. This can work out well: you get to know clients a little more intimately and see what they have hanging on their walls. You might be able to give input not only for the piece you're helping to install, but perhaps by suggesting another piece for another bare wall.

→ Don't expect to get compensation for damage to your work from a gallery because of their poor packaging. They will never take the blame! You have to hope for the best.

→ Recycle! Start saving packing materials from direct mail orders that you receive.

MOVING COMPANIES

Moving companies usually have a 500-pound minimum charge. Cross-country time is several days to several weeks. Vans will pick up and deliver directly to galleries, museums, and private homes and will uncrate articles for an additional fee. Items without glass can be packaged in special van containers.

TRUCK RENTAL

If you intend to transport an entire one-person show, consider renting a truck and driving it yourself.

Chapter 9
Displaying Art

Framing art

Hanging art

Labeling art

Care of art

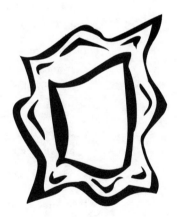

I have a predilection for painting that lends joyousness to a wall.
Renoir

FRAMING ART

A frame is a tool for protecting an artwork. It also should complement the color and texture. It should never overpower the art.

Study framing by going to frame shops, galleries, museums—see what you like and don't like for your own artwork. Since framing is costly, you'll want to train your eye before you spend money. Find a good framer who is knowledgeable and helpful. Before you decide to work with a framer, examine some samples of his work. When you have the eye and knowledge to recommend an appropriate frame to a client, it can make the transaction more professional.

Many artists avoid framing altogether. They wrap their canvas around their stretcher bar, paint over it and call it a frame. For some styles this works quite well. Some hang their work on special hangers or with pins, without frames. If you can figure out your own hanging method, it can become part of your signature look and add to your overall style.

FRAMING TIPS

→ If you are having a one-person exhibit, it is important to frame your pieces in a cohesive way, giving a more professional look.

→ Go to the frame shop or art store and pick out some ready-made frames that go well with your style of artwork. What sizes do they come in? What standard sizes do mats come in? Use canvases the appropriate size to fit these standard frames. Complete most of your pieces in these standard sizes. When you do a piece other than standard size, charge more.

→ The wire in the back should be neither too taut nor too loose. You don't want it to hang beyond the top of the frame. If it's too taut, it's hard to hang. Ideally, the wire should be between one-third and one-fourth down from the top of the frame.

→ Simply done or elaborately contrived, the mat must complement the artwork and not detract from it. Matting can be an art form in itself.

→ The mat color or frame should enhance the artwork.

→ To prevent degradation or damage to paper, use only acid-free mat board. The best mat board is made of 100 percent rag.

→ You don't need a fancy frame to make a piece stand out. You can explain to customers that if they want a fancier frame, you will help them pick the right one out when they buy a piece.

HANGING ART

Hanging artwork in a home or at an exhibition space is not easy. It takes time, effort, and a bit of knowledge to do a professional-looking job. Having an assistant—four eyes—will be a help.

Study the space you will be using before you begin to hang. What color are the walls? What size? Where will you hang what? Artworks should be both a part of the environment and separate from it. Don't hang an art piece as an afterthought. Choose the correct size piece for the space. Art should be the most important item in a room.

▸ Hang artwork at eye level—about 6'6" from the floor to the top of the piece. The average-height person will then look up at the work.

▸ Consider whether people will be sitting or standing while viewing the piece.

▸ A painting should be no more than a foot above furnishings so that you see them as a unit.

▸ Do not touch the surfaces of paintings; oil marks from fingers are difficult to remove. Wear clean old white cotton gloves when working with certain frames and delicate pieces so as not to get marks on glass or frames.

▸ Do not carry a painting by the top of the frame. Carry with one hand underneath, the other at the side to support the structure.

▸ If you are hanging a large painting, share the task of lifting with a second person.

▸ When resting a painting on a floor avoid abrasive surfaces.

▸ Don't hang in excessively cold or damp locations.

▸ If you plan to group works together in an exhibit, the bottom edges of frames should remain on the same line. Place the strongest pieces at either end. There should be a flow and variety about the grouping.

KEEP IT INTERESTING

Intrigue viewers—your potential clients—as they look at each piece. Try to keep them in front of each piece for a bit of time. Have a card with a short history of the piece, a quote that relates to the artwork, or a story. I recently saw this technique at a Lucien Freud exhibit at the MOMA/LA and it certainly enhanced my viewing.

RED DOTS

If someone buys a piece during your show, explain to them that it needs to remain up until the end of the show. (Only in a rare case would I allow them to remove it early.) Be sure to have red dots available to place on labels of pieces that have sold. There is no better way to entice people to buy than red dots on many of the labels.

THE SACRED SALES SPOT

by Margaret Danielak

A sacred sales spot is a "spot" within an exhibition area from where you consistently make sales of your work. For example, at home I have sold many paintings from my sacred sales spot in our dining room. The sacred wall faces to the north and is cut off in the middle by a large window facing the mountains. There is only one light in the middle of the room, under a shell fixture hanging flush to the ceiling. Each and every time I hang a painting on either side of this window and have people over for an art event, someone will buy the pieces that hang on that wall.

One of my artists, when displaying his work at one of our spaces in Pasadena, will sell the painting from the small wall located to the immediate left of the entrance. It doesn't matter if the work is framed or unframed, golden or red: He will sell whatever is hung in that spot.

Each of my other artists has a similar sacred sales spot at the places where we exhibit and sell their work. Try to observe this phenomenon when you have the fortune to sell continuously from a space.

Traits of a sacred sales spot

→ Sacred sales spots are similar in their orientation to the front entrance of the space. Each sacred sales spot faces the street and is located so that the client has to turn around completely (360 degrees) from where he first entered the space.

→ The spot is not obvious but does showcase the artwork, setting it off perfectly, like a great frame.

→ People have to walk a little bit away from the entrance and make a small effort in order to find the sacred sales spot. Clearly, a sense of discovery is vital in creating the sacred sales spot.

Excerpted from pages 109–110 of *Gallery Without Walls* by Margaret Danielak, an art rep, curator, and author. She can be contacted at www.danielakart.com and at her blog at http://gallerywithoutwalls.blogspot.com.

LABELING ART

Study how labels are placed, whether it be at an art fair or a solo exhibit in a gallery.

▸ Labels should all be the same format: same paper, same layout. Use paper that will complement the wall. Some fancy paper can be very inexpensive and adds a nice touch. You can lay out ten labels per sheet. Use your computer printer to print the labels or use nice, legible calligraphy.

▸ When doing an art fair or show, post the price of your work. Yes, I know galleries most often don't, but you're not a gallery. Many people will think a piece is too expensive if the price is not noted, and they don't dare ask the price. If they see a price posted, a potential client might actually become more interested.

▸ Don't put a date on your label (or for that matter, on the front of your painting). For some mysterious reason, buyers think that a five-year-old painting has something wrong with it. They might think you haven't been able to sell it, or that you're trying to "dump" it. Actually, they might be getting one of the artist's favorite pieces, which, up until now, you've not been willing to part with!

▸ A label should include the title, price, name of artist, and medium.

<table>
<tr><td>Valencia, Spain</td></tr>
<tr><td>Oil on canvas by Mary Smith</td></tr>
<tr><td>$700</td></tr>
</table>

<table>
<tr><td colspan="2">Valencia, Spain</td></tr>
<tr><td colspan="2">by Mary Smith</td></tr>
<tr><td>Oil on canvas</td><td>$700</td></tr>
</table>

LABEL PLACEMENT AT AN EXHIBIT

Place the labels on the same side of all individual pieces. It doesn't matter if labels are on the top right side, bottom left side, under the painting, but never put them above a painting. Have all labels in the same position, as in the layout below.

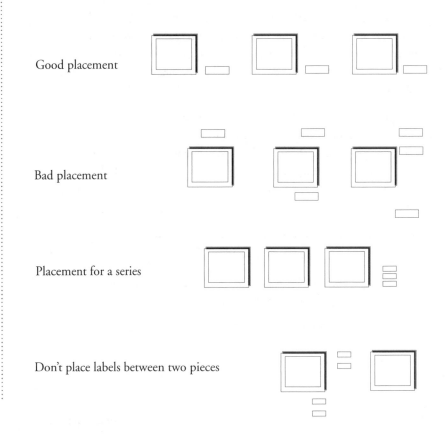

Good placement

Bad placement

Placement for a series

Don't place labels between two pieces

Stacking framed or matted pieces in this manner can work well, especially if you have limited space for display.

LIGHTING

Lighting is an essential ingredient to exhibiting art properly. The amount and duration of light are key factors when thinking about where to put an art piece in an exhibition.

Ultraviolet rays, found in all light and heat, escalate the aging process of dyes, pigments, oils, canvas, and paper. Sunlight can dry out or physically burn an artwork. Paintings should never be positioned directly in the full-flood illumination of a bulb. Artificial light, in the form of fluorescent tubes, incandescent bulbs, and halogen lamps, can be as damaging as natural light.

Lighting experts have devised a plastic filtering sleeve, believed to screen out nearly all of the ultraviolet rays produced by a fluorescent tube. These sleeves are available at specialty lighting companies in most cities.

All lighting systems produce light that in some way alters the way you see your art. Incandescent lights tend toward yellow, while fluorescent light is greenish-yellow; both produce an unbalanced perception of color.

The closest approximation to noon sunlight is the halogen lamp. Move it far away from the viewer and don't over light. Picture lights attached above pictures should be no greater than 25 watts and should be used sparingly. Watch for glare on artworks framed under glass.

TEMPERATURE

- Avoid extreme changes in temperature.

- Do not hang artwork over a working fireplace or a wall heater.

HUMIDITY

- Do not store prints in shrink-wrap for long periods as it might create moisture.

- Do not hang artwork in a bathroom. Excessive dampness permits mold to flourish.

- The ideal climate for paintings on canvas is 50–55 percent relative humidity and a temperature of 65°.

- When cleaning a glass-covered picture, do not spray directly onto the glass— spray the cloth and then clean the glass.

- Do not store paper in tubes, as they may cause acid and staining damage. Pieces on paper should be stored flat, protected by layers of cardboard and acid-free paper.

- Works on paper can suffer irreversible damage in humidity over 70 percent.

CARE OF ART

Knowing how to care for your artwork will benefit you throughout your career. When you inform your clients of care techniques, they may appreciate your work even more.

CARE OF ARTWORK

HANGING AND STORAGE TIPS

→ To transport, put in plastic bag, then wrap with padding for protection (sheets, towel, blanket). Plastic first because fibers and lint from fabric can stick to varnish.

→ Do not place anything on surface of painting.

→ Do not leave in a hot car, especially in the trunk, as varnish can blister.

→ In the case of a painting on canvas, be careful not to lean the painting against anything sharp (corner of table, chair) that could cause denting, stretching, or tearing of canvas fibers.

→ Do not hang in direct sunlight.

→ Do not hang over a direct heat source—radiators, vents, or too near a fireplace; smoke, ashes, and heat damage artwork.

→ Try not to hang in an excessively damp or cold location.

→ Never put water on the surface of any painting.

→ Try not to touch surface of painting—oil marks from fingers are sometimes difficult to remove.

→ If necessary, dust with a clean, dry, soft brush.

Chapter 10
Planning an Exhibit

Finding an exhibition space

The twelve-month exhibition plan

Invitations

Post-show blues

Merchant status

Painting isn't an aesthetic operation; it's a form of magic designed as a mediator between this strange hostile world and us, a way of seizing the power by giving form to our terrors as well as our desires.
 Pablo Picasso

FINDING AN EXHIBITION SPACE

Planning your own exhibition will help you appreciate what a gallery does for you (and why a gallery takes a 50% commission).

It probably has become obvious to you by now that an important aspect of marketing your artwork is making sure it gets seen by the buying public. Many times emerging artists have to create their first exhibition. "Shouldn't the gallery be doing this?" you ask. Before you get accepted to exhibit in a commercial gallery, where the gallery owner will take on most of the responsibilities of an exhibit, you will probably have to have exhibits in a variety of venues.

Finding an exhibition space is a matter of being creative. Local community-event calendars and cultural newspapers can alert you to non-gallery exhibitions that are being held in your area. Check out local art cooperatives, nonprofit spaces, art councils spaces. Be innovative and willing to create your own space:

Bookstore	Church	Coffeehouse
Dinner club	Frame shop	Friend's home
Furniture store	Hospital	Hotel lobby
Library	Nursing home	Shopping mall
Theater	Winery	

GROUP EXHIBITS

A group exhibit, whether it is with one or more other artists, might be the way you'll want to go the first time, due to cost and lack of experience. Don't fret. This can be to your benefit. You'll not only have someone to assist you, you'll most likely have more guests.

You will need to make sure that each artist's obligations and commitments are clear. It is best to write out a plan so that each person can easily remember who is obligated to do what. This might take a couple of meetings, a little typing, and a few photocopies. You'll all decide who is best at, and therefore responsible for, publicity, installation, dismantling, handling sales, invitation design.

12 MONTHS PRIOR TO SCHEDULE EXHIBIT

Just as galleries do, you are going to start planning your exhibit 12 months prior to your intended opening date! That way you won't be totally frazzled with this new task. The first thing you will do is concentrate your efforts on searching in your immediate area for a location to have your exhibit.

MAKE A LIST

Contact the spaces you've decided upon in your area. When searching for the ideal space, consider:

Accessibility for visitors	Cleanliness	Date of show
Insurance coverage	Lighting	Parking
Restroom facilities	Safety of area	Wall space

TIMING

Consider the time of year and the day of the month or week in planning an exhibit that would best suit your needs. Do you want a one-day, week-long, or month-long event?

▸ October through December are good due to the Christmas buying spirit.

▸ Springtime is good—people are coming out of hibernation.

▸ An after-work/before-dinner event, usually on a Thursday or Friday evening from 5:00 to 8:00, works well for many people.

THE TWELVE-MONTH EXHIBITION PLAN

Can the show be associated with a fund-raising event? It's likely to get more publicity if it can.

One of the best exhibitions I've seen was at a private collector's home. This collector wanted to give a party for an artist he was fond of. He had the perfect Mediterranean house—indoors and out—for such an exhibit. He even hired a salesman to assist the artist. It was a cocktail party. No pressure was put on the attendees; everyone had a good time. I asked the salesman (whom I barely recognized as such) before I departed if he had sold any pieces. He said no, he would do that in the next few days. I took his number to check up on the results. By golly! Three days later he had sold one piece, and one week later, two more pieces. One piece was sold to an interior designer who was interested in more for her clients, and the other two to a businessperson—one for her home and one for her office.

Consider your first show a
learning experience.

10 MONTHS PRIOR

You will need to consider monetary costs. How much are you willing to spend?

Refreshments	$ _____		Framing	$ _____
Hired assistant	$ _____		Invitations	$ _____
Photographer	$ _____		Mailing	$ _____
Advertising	$ _____		Site rental	$ _____

THEME

Think of a theme for your show: A catchy idea may win you some press coverage. You'll be planning invitations, refreshments, flowers, and music around this theme—maybe even your artworks will be planned around this theme.

8 MONTHS PRIOR

Confirm the date of your exhibit in writing with a user-friendly letter directed to the building owner or representative. Discuss your hanging plan, refreshment plan, timing, publicity. Make sure the owner of the space understands all the details you have in mind. Can you place flyers/postcards/business cards in an appropriate area when the opening is over?

6 MONTHS PRIOR

Create a publicity plan. Include some wild promotion ideas as possibilities. Start creating your press release including a great photo. Get help editing it. Free publicity receives much better responses than an ad. Only advertise if you've studied the publication and it's very specific to your locale. Consider a barter for the cost of an ad. (More in chapter 14 of this book.)

4 MONTHS PRIOR

Start framing your pieces. Yes, most all of your pieces should be completed four months in advance. No sweating the last-minute details that way.

3 MONTHS PRIOR

CREATE YOUR INVITATION LIST

Besides the people you know, add hotel bellmen, concierges, inn hosts, convention and visitor bureau volunteers and workers, and others who deal daily with tourists in your area.

Previous clients	Friends	Art consultants
Art critics/editors	Relatives	Art school personnel
Patrons of the arts	Museum curators	Newspaper writers
Artists	Arts councils	Local TV personnel

Design the invitations and your email blast.

Mail necessary press releases to monthly publications on your list.

If you have the funds in your budget, start searching for a salesperson to handle your opening. Perhaps hire a part-time employee from a local gallery.

2 MONTHS PRIOR

Mail the invitations.

1 MONTH PRIOR

Mail press releases to semimonthly and weekly publications.

Mail press releases to radio and TV stations. Don't forget your local cable channel.

Plan your opening reception: refreshments, flowers, music, napkins, plates. Make it as simple and comfortable as you can. Stay within your planned budget. Know what printed materials you will have available for people to take home. Arrange for help if need be.

2 WEEKS PRIOR

Call the press (TV and radio, journalists, editors) to see if they can cover your exhibit.

Email your list of clients about the show.

Make phone calls to current clients and let them know about your exhibit. Ask them if you can send an invitation to any of their business associates or friends who might also be interested in coming—or send your clients some extra stamped postcards to send to their friends.

3 DAYS PRIOR

Hang your artwork. Consider both natural daylight and artificial lighting when you hang your show. Allow yourself an entire 12 hours to look at the work in the various lighting conditions. If you can't see the artwork due to reflecting windows or bright lights, how can you expect someone to be willing to pay $1500 for it?

Make your exhibit an annual event—it will be remembered more easily. If you can coordinate it with some special event, this will help bring people to your exhibit. They are already out and about, and another stop can be fun.

Loosen up your crowd with a bit of wine.

DAY OF EXHIBIT

Get there early! Allow plenty of time to set up and an extra half hour so you can relax.

Be a good host: greet every visitor. Encourage interested guests to sign your guest book.

Keep circulating. Have fun; you've hired someone to do the sales.

FOLLOW-UP

Celebrate! Your community has begun to view your art and become familiar with your name.

Handle the dismantling of the show as efficiently as the hanging. The property owner will be very pleased and will recommend you to other venues. Evaluate what worked well and what didn't.

Print the show planning chart out to help you get organized: www.artmarketing.com/artoffice/12monthshowplanner.pdf.

INVITATIONS

You don't need to spend a lot of money on an invitation, mostly creative energy.

When you create any kind of promotional item for your business, be sure it is simple, direct, and "from you." Use your allotted budget wisely. You are starting to design this invitation three months before you need to print it, so you can think and rethink your approach. It is no small matter to create an attractive marketing piece.

A simple postcard—even in black and white—can be striking. Maybe you want to make a more formal invitation—one that's enclosed in an envelope. There are even preformatted invitations available these days that can be printed on a home-office printer.

You'll want an evite (an email invitation) to "match" your mailed invitation, to remind the recipient it's coming from the same person.

It's more important than ever these days to send an invitation for your exhibition that stands out from the crowd. When your invitation is special, it gives a hint of what your opening will be like—special invitations suggests a special night. Everyone loves novelty done with pizazz.

▸ Don't forget to include all the facts: who, what, when, where, why—and clear directions.

▸ You want people to come to the opening; but if they can't, make it easy for them to visit on another day.

▸ Encourage some people with a handwritten note to come early for a private showing.

▸ Use artsy stamps from the post office to go with your design.

THANK-YOU NOTES

Send a thank-you note to all who have assisted in making your exhibit a success. It should be short and sweet—how about with a reproduction of your artwork on the card?

POST-SHOW BLUES

It takes a tremendous effort to put on a show, even when a gallery owner is the one doing most of the presentation. You've finished several new paintings, framed them, couriered them to the gallery, and attended the opening. If you're sponsoring the show yourself, you've done a million other things too to bring it all together. A lot of energy comes your way with all these efforts; all your friends and new patrons arrive. You're the star for the night. Then it's over. Back to creating again. How do you get over the emotional bump at this point and get on with your work?

BE PREPARED

If you haven't been "fortunate" enough to experience the post-show blues, know that it will happen. You have, after all, exposed your spirit—your entire being—to the world. Who will understand? Even if there is positive feedback it's hard to stay on an even keel.

Another emotion that you will have to deal with is parting with your paintings, your "babies." Even though that is what the show is about—that is what your marketing has been all about—it is like parting with a friend, a very difficult feat in the end.

Be prepared: even with a wonderful review, you will still have post-show blues. Do something grand for yourself. Some artists plan to take a vacation, shelving any normal activities in their lives. Some take aspirin. Some go on a spending spree, some a cleaning spree. Some reorganize.

NOTE YOUR DISCOVERIES

▸ What did you accomplish with this exhibition?

▸ How well did it work?

▸ Have your goals now changed?

TIPS FOR CURATING A STUNNING ART EVENT

by Daniel Tardent & Josse Ford

Curating is an art form in its own right. Get it right and your show will be more spectacular than the sum of the individual works of art. Get it wrong and your visitors may wander around bewildered, not "get" the art at all, and leave with unhappy faces!

I recall a very memorable experience in 2005 at the opening of the "3 x Abstraction" exhibition at the Drawing Center in New York. Wandering around the show, I was immersing myself in the exceptional works of Emma Kunz, Hilma Klint, and Agnes Martin. At one point I stood in the center of the main gallery and took a sweeping look around the space. What I saw amazed me—the show looked like a symphony of light in which each painting was a note. It hadn't just happened that way—it was the result of excellent and creative execution of the curator's work.

Next time you organize an art event—be it a solo or group show—be sure to take into full consideration the powerful effects of curating. Here are some useful tips to creating a stunning show.

Plan well in advance

We recommend that you start planning for any art event (even an open studio series) at least three months in advance, preferably longer. There are many steps in the process to a great art show and all these aspects take time.

Choose artists and themes carefully. If it's a group show, choose a fairly small number of artists whose work either complements or contrasts in a way that makes sense. If there are significant variations in theme, you might want to segment the show into different staging areas, like the rooms of a gallery.

Think minimalist: less is more

Have you ever been to one of those shows where you couldn't see any wall space? Art needs room to breathe. The space around the art is crucial to a good presentation. I've noticed a general trend that the more expensive and exclusive the art, the less is placed within a given space. Conversely, inexpensive shows often plaster every inch of wall space with art: it looks cheap and doesn't showcase the work well.

Visit excellent art exhibitions

Learn from the professionals by going to a significant art exhibition at least once every week, an art museum, commercial gallery, or open studio. By attending art events regularly you'll quickly get a feel for the style of curating you would like to model in your own show.

See the big picture

Just as I experienced at the Drawing Center, you too can create a show which is a symphony of light and creativity. My recommendation is to spend time with all the art pieces inside the actual exhibition space at least a week in advance of the show. Take some wonderful music, good food, and spend at least two days working with organizing the art. Let each piece speak to you. Keep your heart open and take risks. Don't get left-brained and analytical. Allow the symphony to unfold.

Enjoy the show

It's so amazing and rewarding to see how visitors react to all that creativity you've invested!

Daniel Tardent & Josse Ford are the owners of www.beautifulartistwebsites.com, a design studio based in California. They create beautifully designed online-marketing systems that showcase, market, and sell artists' work.

MERCHANT STATUS

It is imperative in this day and age for you to be able to accept credit cards. You will miss sales opportunities if you are not set up to accept them for purchases. Accepting credit cards these days is relatively easy if you go through one of the online services most people are familiar with. The fees you pay are not any higher than if you were set up like the big retail stores. The 3 percent or so service fee is well worth the deductible expense.

The easiest method these days is Paypal.com. Almost everyone has an account there. Alternatively, look at Checkoutgoogle.com.

If you do a tremendous amount of sales online—prints, cards, miscellaneous—you might want to gain "merchant status" at your bank of choice.

A new device, that you can attach to a smart-phone when you are on the road, has recently become available. Going by different trade names, google for it online.

BENEFITS OF ACCEPTING CREDIT CARDS

- Spur-of-the-moment buying is prompted

- Convenient for telephone and computer orders

- Security and peace of mind for your customers with a guarantee from the card bank

- Quick deposit: a bank generally applies the charge within three days to your account, whereas they might hold an out-of-state check for a week or more

Chapter 11
The Internet

I want to put a ding in the universe.
Steve Jobs

WEB SITES

Keep in mind that you have eight seconds to hold the attention of your viewers as they click on your URL.

A web site is the best tool you can have these days to promote your art—it's a must! Your web site is your portfolio and is nothing short of having your own gallery space. Spend time creating a great presentation; it will pay off.

CHOOSING A URL

Think carefully about the name you choose for your URL—your web site address. It will be part of your "branding." (See chapter 12.)

▸ Your URL should be no longer than 20 characters—the shorter the better.

▸ A dash, period, or unusual character will make your URL more difficult to verbalize, as well as to type correctly.

▸ Make sure it is easy to pronounce and spell.

▸ Your fictitious name or personal name could work the best.

DESIGNING YOUR WEB SITE

Designing web pages can be frustrating and time consuming, but it also can save lots of money. Think carefully about the process, before you decide to design your own web site.

▸ Have you done design work before? Are you a graphic artist? Do you like working on design programs on computers?

▸ Are you willing to devote several hours to learn how to use a software program for building and eventually updating a web site?

▸ Are you willing to give up art-creation time for computer learning time?

▸ Do you have a fairly new computer to make the process easier?

If you decide to design you own web site, take a class that is being taught with a software program that is compatible with your computer. Read some web design books to help you with the process too.

CHECK OUT OTHER SITES

Whether you design your own site or involve a professional designer, you will need to know what overall look you want: style, theme, background color. By looking at other artists' (and non-artists') sites, you can get clues to your future web presentation. Print out pages you like while you browse around the Internet, highlighting specifics what you like. Also print out pages from sites you *don't like*. Make a note of what you dislike. In this manner you will realize what you want to emphasize on your own site.

▸ What background colors attract you?

▸ What types of layouts do you like: centered, flush left

▸ What features do you like: music, rotating images, whimsical, fun

SITE MAP

A site map is an outline of what pages you want your site to include. Ask yourself, "What will viewers want to see when they arrive at my site?" Whether a designer is involved or it's a DIY (do it yourself) creation, you'll need a site map as an outline. Creating an outline of the pages you want will help you plan your site in a more organized manner.

▸ Images of your artwork, noting the medium, size, title, price. You could divide your extensive inventory by dates, genre, sold/not sold—you get to decide. Think how your collectors think: what would they prefer when browsing your site?

▸ Exhibitions: list both forthcoming and past

▸ About the artist: bio, artist statement, mission statement, vision statement, photo of you at work creating, short video, a special story to capture collectors' interest

▸ Contact info: email, phone, possibly address, Pay Pal link, blog link

▸ Media center; photos the press can download easily, articles that have been published about you, press releases you've sent out

▸ Links: favorites, business-wise and other

▸ Testimonials from clients

▸ Announcements of openings

▸ Guest book: people can sign up with their email address to receive your newsletters and show announcements

▸ Archive of newsletters you've created

▸ Pages that attract collectors: an article such as "What is a giclée?" or a list of local art events customers can reference and rely on

SAMPLE SITE MAP

Homepage

 Contact info—email, telephone

 Guest book sign-up

 Blog link

 Introduction

 Links to rest of pages

Artwork

 2012

 2010

 Abstracts

 Landscapes

 Commissions

 Prints

Calendar

 Ongoing shows

 Upcoming shows

Media center

 Reviews of artwork

 Testimonials

 Pix of artist

Viewpoint of artist

 Video reviews

 Book reviews

 Newsletter

History

 Bio

 Statements: artist, mission, vision

 Life story

Links

 Favorite links and cool sites

Purchasing

 Shipping and handling policies

 Terms of purchase; guarantee

 Shopping cart

Some ideas to remember while creating your web site:

→ Clarify your personal goal regarding your site.

→ Pick a theme.

→ All web pages should look cohesive: Keep your header and footer on each page consistent.

→ The font you choose should be easy to read and not too small. Make sure the color of the type contrasts well with the background color. Use light backgrounds for text.

→ Speed is an important design factor. Each page should download within 5–10 seconds. Test and check each page.

→ List your prices.

→ It's fine to exhibit artwork online that has sold (noting, of course, that it has sold). A "sold" tag entices viewers.

→ Be sure to list sales you have made to well-known collectors on your bio page.

→ Post any new artwork or openings on your home page, with a link to a more detailed page.

→ Show that you are a specialist in your art field.

SELLING ONLINE

Encourage people to overcome hesitancy of online purchasing:

▸ Have a 30-day approval

▸ Have a money-back guarantee

▸ Take installment plans

▸ Provide a framing service

▸ Provide house installations

GENERAL DESIGN TIPS

For a visual artist, quantity of visitors is not the point; quality of visitors is more important.

THE BIGGEST MISTAKES IN ARTISTS' WEB SITE DESIGN

→ Low-quality reproductions

→ Takes too long to download a page

→ Confusing navigation

→ Links that don't link anywhere

→ No place to capture your visitors' email for future marketing

→ Your data—name, email, telephone—is not easily found

→ Too flashy and time-consuming

→ No prices listed

→ Too many banners and unnecessary ads

→ Pages don't print out easily on a standard sheet of paper

→ Visuals are not consistent, creating confusion

WEB DESIGNERS

Web designers generally charge between $65–100 per hour. The fact that they charge a lot doesn't mean they are fast.

TIPS

→ One way to choose a web designer is to surf to a web site you like and see who designed it; often the designer's name and email are at the bottom of the page.

→ Find a designer who can do both the behind-the-page (coding meta tags for search engines) and exterior design (the visual look).

"BEHIND-THE-PAGE" DATA

Behind-the-page data—meta tags—is the data that is hidden to the viewer but visible to search engines. Meta tags are the elements that can get web sites to the number one position on a search engine.

COPYRIGHT OF WEB PAGES

When you hire a web designer to build your site, it becomes the copyrightable artwork of the designer—just as when you create a commission for someone, it is your copyrighted image, not the buyer's. If you want to change or update the site yourself in the future, or hire a different person to update it, you cannot! The only way to avoid this inconvenience is to have a written agreement with the web designer indicating that you own all the rights to her creation and that you can change it as needed. If the web designer doesn't agree to that in writing, find a different one that will. Otherwise you will be stuck with that designer.

WRITTEN CONTRACT WITH WEB DESIGNER

Get a comprehensive quote in writing. The preliminary site map you've created should help this quote be more accurate.

▸ Agree on copyright ownership.

▸ Agree on cost of initial development and what it includes—number of pages

▸ Agree on cost for updates

ATTRACTING BUYERS TO YOUR SITE

Always note your website when sending an email.

Let's not kid around and pretend that having a web site is a magical cure-all to make a sell. You still have to find ways to promote and attract your particular genre of client to your site. As a fine artist you will not be thinking of promotion in the same way a large company does. You need to think about attracting individual, quality clients.

- Concentrate on certain key art professionals such as interior designers, corporate art consultants, architects, private collectors, publishers, licensors.

- If you have a specific genre—pet portraits, people portraits, landscapes, vineyards—market toward that group.

- Use the social network sites to bring people to view your art (see page 119).

- Create a "Recommend" list.

- Offer a freebie on Craigslist.

- Start a blog such as "What Art Collectors Need to Know" or declare yourself an expert at something. Use that expertise topic to initiate your blog. If it's not directly related to your art, figure out how it could be. Make sure your blog has an RSS feed.

- Upload a video on YouTube that links to your site.

- Exchange links with appropriate sites.

- Write an article: offer it to appropriate sites.

- Offer the use of one of your art images to another site, making sure they note your web site with a link.

- Join art organizations, including your local arts council, and create links to your art site.

- Design a web page that lists your personal favorite sites; see if they will link reciprocally.

→ Be sure your email signature has your URL.

- Participate in a forum (see www.gaiaonline.com and www.artfreaks.com).

- Interview yourself and post it on your web site and on YouTube.

- Create a short, free ebook and give it away. Be sure to include a link (within the document) back to your web site. Offer your short, free ebook to other sites to distribute.

- Participate in Yahoo Answers. As a specialist on a topic, you can answer questions and inform people of your blog or web site (www.answers.yahoo.com).

▸ Review books on your area of expertise. Create a book list related to your style of art—"My Top10." Post it on Amazon.

▸ List your openings on other sites that have calendars (local art organization). Also try Craigslist, www.artline, www.flavorpill.

▸ Have a title contest for one of your new art pieces and give away a print of it as the prize. Perhaps holding such a contest on a monthly basis will bring clients back regularly.

▸ Ask visitors on your site what they would like to learn about.

▸ Offer an online gift certificate which your patrons can purchase for a friend.

▸ Mail a gift certificate on a postcard to draw people to your Open Studio and URL.

▸ Upload press releases you've sent to the press onto your site.

▸ Use Twitter, Facebook, LinkedIn to draw people to your site (see page 119).

▸ Verify that your URL comes up in search engines.

GETTING RETURN VISITORS

Don't forget to put your URL (and logo) on all your promotional materials.

Once you have interested parties visiting your site, you don't want them to disappear and never return. Here are a few strategies to get return visitors:

▸ Make it easy for them to sign up on your guest book so you can send them email reminders about special sales or events.

▸ Update your site monthly with something of interest.

▸ Have some gimmick; a special "gourmet" section, a "Recommended art books" page, review of art-related videos.

▸ Every month offer a special price on one original piece: first come, first served. Let it be known on your entry page that you do this.

▸ If you auction on eBay, let visitors coming to your site know this fact.

▸ Offer something free: a free print with the purchase of an original.

▸ Email your guest list informing them of the completion of a new piece.

▸ What do you do best outside of art? Travel? Cooking? Add a page referencing that to your site; entice them to return.

▸ Create a calendar of events of major art shows, specialty art shows, local openings of interest that your clients can rely on.

▸ Tell a story on your site, unique to you, and unforgettable!

▸ Display a photo of you creating.

Site innovation

→ One artist created a great web site with "Dorothy's Page." Dorothy is a fictional twin sister who confiscates Doug's artwork and sells it behind his back at a lower price. This idea got me to bookmark his site and go back there periodically to check on possible sale items.

→ www.traceyporter.com has a link for "Dreamers and Entrepreneurs." This link caught my attention. I clicked it on right away.

EBLASTS

Emailing to a large list of art professionals to introduce them to your site and artwork or invite them to your exhibition can pay off. There are a variety of online sources that will blast out your online ad to art world clients. In some cases you prepare an HTML document, in some you prepare just the copy. It is sent out on a particular day, with a particular subject line. Generally you will receive stats back about how many of your emails were opened, how many people continued to click to one of the links.

▸ ArtNetwork - www.artmarketing.com/e-mailblasts.html

▸ E-flux - www.e-flux.com

▸ Art Agenda - www.art-agenda.com

▸ Visual Arts Network/VAN - www.visualartsnetwork.com

▸ It's Liquid - www.itsliquid.com

▸ e-flash - art-of-the-day.info

▸ e-artnow - www.e-artnow.org

▸ Professional Artist Magazine - www.professionalartistmag.com

▸ Artist's magazine - www. artistsnetwork.com

IN-HOUSE LISTS

Constant Contact - This company will take your in-house email list and blast your document to them. Pricing, which depends on the size of the list, can be as low as $15 for 500 contacts. It will provide you with stats as to how many people opened the email, how many people clicked on. Offers a 60-day free trial. www.ConstantContact.com

Emma - Pricing is based on number of emails her month; as low as $30 for 1000. Offers a 60-day free trial. www.myemma.com

Get Response - Pricing is based on size of list; as low as $15 for 1000. Offers a 30-day free trial. www.getresponse.com

MailChimp - As low as $10 for 500, less for nonprofits. www.mailchimp.com

ONLINE PROMOTIONS

Keep it personal.

SOCIAL NETWORKING

Keeping up with social networking is a daily activity.

Much like in-person networking, social networking consists of communities of people who share interests or activities. Using social media to its utmost can help drive traffic to your site and ultimately bring you sales.

Art and design networking sites include Art Break (www.artbreak.com) and Art Rise (www.artrise.com) where artists gather and exchange information. Also explore Facebook, Flickr, Twitter, LinkedIn (see article on next page).

You must personally weigh the time and effort versus the result and see what brings you the best outcome.

KICKSTARTER

At this very second, thousands of people are checking out projects on this fund raising web site—Kickstarter. Every project is independently crafted and supported by friends, fans, and the public in return for rewards. Artists you see on Kickstarter have complete control and responsibility over their own projects. They spend weeks building their own project pages, shooting their own videos, and brainstorming what to offer as rewards. Every project creator sets her project's funding goal and deadline. If the project succeeds in reaching its funding goal all backers' donations are charged. If the project falls short, no one is charged. Take a look at this innovative site—www.kickstarter.com.

SOCIAL NETWORKING

by Barbara Markoff

The use of social networking sites by business owners is huge and growing exponentially every day.

LinkedIn is set up to organize contacts and promote your business. The first step is to complete a profile listing details about your position, company, education, work experience, and interests. Upload a photograph and invite business contacts to connect with you.

LinkedIn is a great marketing tool and a way to discover new contacts that may need art consultation services. The site allows you to develop a network of contacts referred to as connections. Added by mutual consent, users of LinkedIn may not only view their own connections (second degree of separation) but they can view the connections of their connections (third degree of separation), putting them in touch with another layer of potential high level people to interact with. This third degree of separation opens opportunities to explore new contacts and expose your professional information. Upon request, the user can ask for their mutual contact to introduce them, thus easing the barrier to communication.

When I collect business cards from networking events, the following day I request to connect with these business people on LinkedIn. Through the site, it is easy to send emails to your connections, some of whom otherwise have hard emails to remember. Invariably, people tend to move from company to company and change emails, but people do update their LinkedIn information, making it easy to follow them.

Another feature of LinkedIn is the ability for members to join groups with like-minded individuals. In these groups, you can find artists, interior designers, architects, and other professionals that should know about you. Group members post questions and comments about business related subjects, opening up a forum to exchange ideas and information. For example, LinkedIn has groups called Creative Art Consultants, Healthcare Fine Art, Professional Fine Art Network, and Fine Art in the Workplace. By joining these LinkedIn groups, you have access to numerous professionals who are involved in the arts.

In San Diego, I attend a LinkedIn-based networking group with other business people. The members meet at different venues around the city to network. Since LinkedIn has brought us together, we exchange tips and strategies about using LinkedIn. Recently, I came away from a meeting with several excellent contacts and three leads to companies needing artwork. The use of LinkedIn has saved me time and effort in discovering who is spending money in San Diego.

🖋

This article was excerpted from pages 27–28 of *Becoming a Corporate Art Consultant*, published by PFM Books, a division of Hobby Publications. The author can be contacted at barbara@theartconsultant.biz or www.theartconsultant.biz.

OTHER METHODS OF PRESENTING YOUR ARTWORK

SMARTPHONES

Now you can carry your portfolio with you wherever you go—in your phone. Be sure you have your best pieces and not too many. Entice the viewer sitting next to you to go to your web site at her convenience by leaving her with a business card with your URL.

POSTCARDS

You may have noticed lately that you're not receiving as many advertisements through the mail as you did several years ago. Companies are using emails more and more to advertise to the consumer. All the more reason for you to contact your special customers periodically with a postcard through the mail.

The most common presentation through the mail these days, and least expensive, is a postcard showing a typical example of your artwork—maybe your newest piece. A postcard can be a simple reminder to attend one of your openings, an ongoing exhibition, an open studio event, or it can be an invite to a private Christmas showing. Emails are great, and free, but a postcard can seal the deal. Always note your web site and have a special web page on your web site relating to the postcard's information.

Send cards to your in-house list that you've gathered manually through research and by people signing up during your open studio via your guest book, as well as to those that have signed up while browsing through your site on your online guest book.

If you want to reach new audiences, rent a list in a specific category: corporate art consultants, interior designers, museums, architects, and more are available at www.artmarketing.com.

POSTCARD PRINTERS

Postcards can be ordered via your computer and arrive at your doorstep amazingly fast. It's so much simpler than it used to be! Prices vary only slightly from company to company. Some print on glossy stock, some on matt. You can get as few as 250 4x6″ 4-color back-and-front postcards for $35; 1000 for $50 plus shipping. Can't get any cheaper than that! Our favorite online sources are www.gotprint.com and www.1800postcards.com.

Chapter 12
Branding

Creating a memorable brand

Photographing your artwork

A fool is a man who never tried an experiment in his life.

Darwin

CREATING A MEMORABLE BRAND

Branding has become a buzzword in business today. We know of big-name companies—Coca-Cola, Nike—that have taken their name and, through their ads and press coverage, created a type of identity that gives them a certain "flavor." When a book publisher has a series of books—*For Dummies*—they create a certain cover look they use over and over again. It's easy to spot when looking in the business section of a bookstore. These are great examples of branding.

Individual artists can brand themselves by the way they present themselves as well as by their style of art. Your web site should have the same feel, or brand, as your artwork.

FICTITIOUS NAME

Why have a business name—why not just use your own name? Sometimes a fictitious name can create a great brand identity. Your business name can summarize your style, subject matter, or philosophy in art—and that's what it should do! Make it show clearly who you are and what you do.

You don't have a fictitious name (aka, trade name, dba) for your business? If you decide to create a fictitious name for your art business, don't rush it. Spend time brainstorming with friends and family. Don't finalize any name until you are certain that it's a good one. Test it out. Make sure it creates the image you want—your brand—for you and your artwork. Search online, brainstorm, test, retest, and brainstorm again.

When you've decided on the perfect business name, you will need to go to your local County Clerk's Office to register the fictitious business name. They will verify that no one in your area is doing business with that name. You will have to place an announcement in the local newspaper. The total cost will be around $25–50. Don't neglect registering it. You will be giving birth to a new entity, one that will be your identity for years to come.

CREATING A FICTITIOUS NAME

You want your words to create a visual that will help potential clients remember you. Some examples of some good business names for artists are:

European Expressions	Renegade Art
Spirit House	Country Habits
Visions Realized	Long Skinny Picture Company
Art for Peace	

Not such good names for an artist might include Gordon's Art or Tristan Marketing. They don't say anything creative, fun, or descriptive.

MAKE YOUR BUSINESS NAME

▸ easy to say and spell

▸ simple to remember

▸ create a visual image of your style of artwork

Find out before you adopt your new business name if a URL is available for it.

BRAINSTORM

In preparing to describe your work and business to others, it will help you to understand it better yourself. Create a list of words you can use for your fictitious name as well as a tagline. Use a thesaurus and search online for additional words.

Describe your major art style: Be very specific.

How long have you worked in your present style?_____

Describe your most frequently used medium and techniques:

Describe your major subject matter:

Exactly what are you selling (prints, originals; watercolors, acrylics, oils)?

What characteristics of your work makes it "yours"? Be very specific.

1. _____

2. _____

3. _____

4. _____

Sometimes artists use their signature as a logo.

What are the strong points of your work?

List individual words that describe your artwork: _____

List word combos that describe your artwork: _____

Your business name is the element from which all the rest of your presentation will spring. If you pick too trendy a name, chances are it might not mean anything in several years. You don't want to change your name, so try to use common sense when considering a cliché. Don't rush into some name you won't be happy with in the future.

LOGOS

A logo is the visual expression of your business. It must leave an impression on the viewer. It is something that people more often remember than your business name. It is an integral part of your public identity. The logo needs to "go" with your company name.

Your logo will be on all promotional materials, possibly even on your paintings (or on the back). It is your "trademark." Spend time studying logos in the Yellow Pages or online. It will become part of your header online on each of your web pages.

If you feel unable to design your logo, find a graphic artist who is adept at logo design. If you're fortunate, you can do a trade with the designer for one of your art pieces. Make sure you can communicate well with this designer. You should have a good idea, though not too rigid a one, of the direction you want the designer to go with the logo.

A GOOD LOGO:

▸ photocopies clearly

▸ is easy to read, not too complex

▸ is distinctive and aesthetically pleasing and creates a positive reaction

▸ wears well over time

▸ has impact and is memorable

TAGLINES

A tagline is similar to a slogan: 7-Up's well-known tagline is "The Un-Cola." The tagline, along with the logo and company name, help define the product. (Yes, your artwork has become a product if you are selling it.) A tagline should note the physical features of your artwork, the emotional aspects, and the special qualities. As an artist, you also want your tagline to help define the style or subject matter of your artwork, just as your business name and logo do. Play with the answers to your previous questions and use them below.

List 10 emotional words that describe your artwork

_____ _____

_____ _____

_____ _____

_____ _____

_____ _____

Do any of the words below evoke your artwork? Use them to help you create a phrase:

affordable	awesome	charming	controversial	distinctive
dramatic	economical	flamboyant	forceful	hating
high quality	powerful	provocative	quiet	sophisticated
tranquil	way out	whimsical		

The following taglines all give a specific image to the reader. The reader can relate to these descriptive words:

You're in Good Hands (Allstate)

The happiest place on earth (Disneyland)

When you care enough to send the very best (Hallmark)

Just do it! (Nike)

Think different (Apple)

Don't leave home without it (American Express)

Taglines should be about four to seven words—concise—stating the main benefit. It can be witty. It is hard to forget.

If you expect first-class treatment from an art world professional, you need to contact that person in a first-class manner.

The taglines below are too vague and unemotional. Remember that you are trying to help the reader create an image of who you are and what you do, possibly without seeing your artwork.

Fine Artist: Doesn't say anything, except that you create art.

Watercolor Artist: I want to know more than just the medium.

Landscape Artist: Be a little more specific; there are thousands of landscape artists.

Famous Artist: How come I don't know about you?

The primary benefit of a good tagline is to help get recognition of your work among the buying public. Like a business name, an appropriate tagline is not found overnight. Brainstorm with friends. Ask their opinion.

Once you've decided on your business name, logo, and tagline, you will incorporate them into your web page, letterhead, business cards (yes, people do still use these!), postcards, and invitations.

TIPS

→ Talk into a tape recorder while you work: try to capture in words the feelings or emotions you're experiencing.

→ Talk to another artist or teacher; verbalize your feelings about your work and take notes.

The combination of the right business name, logo, and tagline can make all the difference in the world for a company's success or failure.

If you create great work but your presentation skills are nominal and your web site is haphazard and doesn't match your overall style, you will be defeating your aim.

When I receive a well-made promo piece—postcard, flyer, letter, or email—it suggests to me reliability, seriousness, and commitment—a good first impression.

To attract certain groups of art professionals your way, you must look like you're in business—and in business to stay. No fly-by-nights wanted! If your postcard is haphazard, it might be assumed that your artwork is also haphazard and you are not serious about your career.

Marketing is an ongoing venture, occurring throughout the life of a company. As an artist, you need to plan a series of actions for a length of time (you'll do this when you reach Chapter 15).

BRAND IDENTITY STATEMENT

by Bob Baker

You should craft your BIS to include a benefit statement to your customers. Two well-known examples:

Domino's "Fresh, hot pizza delivered to your door in 30 minutes or less, guaranteed." (13 words)

M&M's "Melts in your mouth, not in your hands." (eight words)

The BIS I use to promote my Quick Tips for Creative People email newsletter is "Inspiration and self-promotion ideas for artists, writers, performers, and more." And for the music newspaper I used to publish, the BIS used to lure potential advertisers was "Your direct link to St. Louis music and entertainment consumers." Here are a few possible BISs for other creative offerings: An illustrator might use "Vibrant colorful artwork that compels clients to read your ads and brochures." A poet could try "Personalized poetry for holidays and special celebrations." A band might use "Erotic techno grooves for sensuous souls."

The ideal BIS tightly focuses on exactly what you do and how it benefits the person paying for your talents—it leaves no doubt in the prospect's mind as to what he gets from you.

You can use your Brand Identity Statement in two ways: internal or external.

Internal

A BIS keeps you focused on your marketing message. Every time that you write a news release, set up a photo session, do a radio interview, or design a brochure, you make certain your vision stays focused on your brand identity. You wouldn't want your business card to convey humor while your promotional postcards are grim and serious. A BIS keeps your marketing message tight and consistent. You don't want to send out a news release about your web design firm's new service for musicians, then do a radio interview and end up talking only about the night you met Pat Sajak. By constantly referring to your BIS, make sure the messages you send out to the public stay focused on the most potent aspects of your creativity.

External

You can also use your BIS as a personal slogan that appears on all of your flyers, news releases, web pages, posters, T-shirts, stickers, and more. That way, whenever someone sees your name or hears about your project, she will be reminded of your core identity and why she should spend her time and money on your product.

Some real-life examples of Brand Identity Statements in use today:

→ Canada's Helios Design and Communications uses "Hard-hitting design, done right the first time."

- → H&B's music catalog claims to be "A mail order service for people who know jazz."
- → Copywriter Luther Brock, who calls himself "The Letter Doctor," uses the phrase "High-response sales letters for firms on a limited budget."
- → Chicago's Smart Studios promotes itself with the BIS "Great sounds. Cool people. Killer studio."
- → The fiction-writing software program Dramatica Pro is described as "The creative power tool no writer should be without."

Find your own BIS. Then use it to stay focused and hammer home your primary marketing message to the masses.

Commitment statement

"I never 'wing it' when it comes to marketing my creativity. I now use a powerful Brand Identity Statement to promote myself. I use my BIS to develop a consistent, needle-sharp vision and focused public image of my unique creative niche."

Today's Action Step

This one should be obvious. Get out your journal and start brainstorming on a possible Brand Identity Statement for your unique style of creative expression. Don't just write one or two possible phrases. Keep your thoughts flowing and your hand moving across the page. Take a break and reread today's lesson. As new ideas for a BIS pop into your head, write them down. Play with the wording. Mix and match phrases. Then look over your growing list of statements and start rating them on the criteria mentioned earlier. The best BIS will be short, to the point, descriptive, attention-getting, and rich in benefits. Take a few days or so to mull over the possibilities before deciding on a final BIS you will use.

This article was excerpted from Bob Baker's *Unleash the Artist Within; Four Weeks to Transforming Your Creative Talents into More Recognition, More Profit and More Fun.* www.bob-baker.com

PHOTOGRAPHING YOUR ARTWORK

Photography techniques have changed radically in the last few years. With digital cameras, cell phones, and the Internet, you can email a visual of a new piece, or a piece in progress, practically instantly.

Reproductions on your web site may be the only way a juror, gallery owner, or consultant will see your artwork. Poorly presented reproductions will make a gallery owner wonder, "Why are they even bothering?" Even though all the equipment is at our fingertips, taking a quality picture still takes a bit of time and talent.

Each time you complete a new group of work, you will need to photograph it, as well as copyright it (see page 64).

GUIDELINES

▶ Try to photograph your artwork before it is framed.

▶ Use a tripod. Square up the picture before you snap the shutter. The camera should be exactly perpendicular to the artwork's surface and at the exact center. If not, you will get distortion and an angled reproduction.

▶ Try to photograph in daylight on an overcast day—indoor lighting takes a huge amount of equipment. Avoid tree shadows, cloud shadows, or patterns of light filtering through houses. Natural, but not direct, sunlight is best.

▶ Eliminate the background if possible. Viewers want to see the art piece. Use a simple, clean, neutral background or wall. A good piece of black, unfolded velvet is a great neutral background.

▶ Take several shots of the same piece—at least five.

▶ Do not put varnish on your paintings until after you have photographed them. That way, you can avoid glare.

HIRING A PHOTOGRAPHER

If you've decided you are not capable of photographing your own artwork, you will need to look for an appropriate photographer. You not only need to find a good photographer but one who specializes in fine art.

▶ If you live near a college, see if the art department has a photography division. You might find some very good photographers at a reasonable price.

▶ Look in the back of your local art newspaper. Usually you will find an ad for a specialist in the field.

▶ Ask an artist friend.

▶ Call a local gallery or museum for a recommendation.

▶ Search Craigslist.

A bad photograph is blurry, has light reflections, is not full frame, has a distracting background, and the color isn't anywhere near the original.

THE HIRING PROCESS

Hiring a photographer is expensive, so you don't want to make a bad choice. Here is a list of things to find out before you actually hire someone.

▸ Get references and check them out.

▸ Look at samples of his work. Has he photographed two-dimensional work before?

▸ Know the fee specifics before photographing begins. Get a quote in writing.

▸ The photographer has the copyright to the pix that he takes of your artwork unless he signs off in writing; make sure he signs off.

▸ Find out if the photographer has a customer-satisfaction guarantee.

WEB IMAGES

The most important part of displaying your artwork online is to start with a good image. Once you have a digital picture of your artwork, you will need to adapt it to the web by using a photo imaging program. Photo imaging software programs easily create jpg's for online use.

TIPS

→ Since small images are faster to download online, give your viewers the option to choose which piece they want to see enlarged by listing a small thumbnail image first. Large pieces should be no larger than 500 pixels in any direction. That way, the entire piece will be viewable on most monitors.

→ A jpg's resolution should be 72dpi (dots per inch)—no higher.

→ Break down web pages into sections, with no more than 20 thumbnails on one page.

Chapter 13

The Word

Imagination is more powerful than knowledge.
Albert Einstein

PREPPING

Read other artists' resumes. What do you like about theirs that could apply to yours?

The "to-dos" seem to never stop when developing your own business—your own way of living. You are getting there though! If you have progressed to this chapter, you have gained immense headway. So keep plugging along.

With a little help from books, seminars, friends, and your own persistence, you have been able to realize that business is also a creative outlet. The myth about the artist failing at business hopefully has left you. You now see a successful road ahead.

It's now time to use what you have learned in the past chapters. You will be compiling some facts and creative thoughts into what we term as various "statements." You will be using your writing skills. If you think you don't have writing skills, they will develop by following the pathway we guide you along.

The three types of statements are categorized as artist statement, mission statement, and vision statement. Along with these three statements you will be composing a resume—sometimes referred to as a bio or vitae. The main reason you are going to spend time and energy developing these statements is so you—and eventually your audience—are clear about who you are, where you are heading, and why. This clarity will change over time, and rightly so—it's a natural process of growth and maturation, just like a fine wine.

ANALYSIS

If you've been keeping a daily journal, then you will be readier for these next projects than those who have not.

Use your thinking cap to fill in the blanks on the following pages—this won't be done in one sitting. Do this throughout the coming weeks; fill it in as ideas pop into your head. Carry a pad with you and write down thoughts as they occur.

ART ANALYSIS CHART EXAMPLE

Use these examples as an idea prompter for the chart on the next page.

Strengths I presently have: good connections in the community; a thirst for business knowledge; an interest in composition; have original ideas for marketing; am a good planner; gentle, aggressive, natural sales person when I like something; no health problems

Weaknesses I presently have: impatient, anger quickly, think I know what I need to do, don't like to fail, limited time for business (due to family and work), want to only be the boss, lack of computer skills, lack of time management, don't know where to begin, need a coach but don't have money to hire one, non-writer, shy, hate promoting myself, hate getting rejected

Resources at hand: computer availability for online research, fellow artist acquaintances, business acquaintances (uncle, friend), community art council, library

Major style of my art: abstract, bright, generic, pet-related, avant-garde, sculptural, two-dimensional

Medium and how used: oils, acrylic, bronze, recycled materials, mixed-media. I use my fingers, I use no glue to attach my recycled material, I use one contiguous wire to create my sculpture

Subject matter: varies: abstract, pets, bridges, landscape, roses, people

Product: framed/unframed, two-dimensional art, three-dimensional art, reproductions

Characteristics of my work that makes it mine, perhaps my trademark: radical colors, emotional content, hubcaps

My theme: outdoors, animals

How long I have been an artist: 17 years

My ideas come from: daily activities and thoughts, people's requests, observing expressions

Feelings and emotions I have during the creation of my work: anxious, calm, floating, happiness, relaxing, free

Response I want from my audience: emotional reaction

Artists I admire, famous or local: Chuck Close, Sam Rascy

Strong points of my work: makes people smile, comfortable for viewers, understood

My artistic passions: finishing a piece, having someone admire my work

Weaknesses of my work: people seem to be afraid of it, unsure of pricing, not sure how to hang

Critics' comments about my work: egotistic, easy to gaze at

Three reasons why people ought to own my artwork: Refreshing, colorful, cheerful

ART ANALYSIS CHART

Strengths I presently have: _____

Weaknesses I presently have: _____

Resources at hand: _____

Major style of my art: _____

Medium and use of: _____

Subject matter: _____

Product: _____

Characteristics of my work that makes it mine, perhaps my trademark: _____

Theme of my work: _____

My ideas come from: _____

Feelings and emotions: _____

Am I trying to get a certain response from my audience? _____

Artists I admire, famous or local: _____

Strong points of my work: _____

Weaknesses of my work: _____

Do viewers understand my work? _____

Have viewers understood, misunderstood or misinterpreted my work? _____

My favorite quotes: _____

Three reasons why people ought to own my artwork: _____

PRINT THIS BLANK PAGE FOR USE IN THE FUTURE

A resume, sometimes called a bio or vitae, is a list of the "vital statistics" of your art career. You can format a rough draft of your resume by simply making a list of art activities, using the categories on the following pages, as an outline. Once you have listed as many items as you can under each category, sift through them to see which ones are the most pertinent for your final resume. Resumes generally do not include all the categories listed: Select the ones you think are the most important to show off your career. The purpose of an artist's resume is to provide a gallery director, dealer, curator, grant-making panel, or client with your achievements and credentials in the art world.

THE 20-SECOND GLANCE

Most readers of a resume give it less than a 20-second glance! The physical appearance and layout, therefore, are extremely important so that it *can* be read quickly. You want to make it simple to inhale in one fell swoop.

RESUME TIPS

→ Be selective; list only key exhibits, awards, and purchasers.

→ One page is best.

→ Neatness counts: no handwritten additions. Computer-generated only.

→ Update every six months. (Hopefully you will be marketing enough to add something every six months.) As time adds more achievements, you will eliminate the less important ones. Keep it to one page.

→ Incorporate your logo, tagline, and business name on the page.

→ Proofread diligently. Be scrupulous about the accuracy of your typing. If someone types it for you, be sure to proof it again before printing or uploading online.

→ You might want to keep a "documentary" resume that has all your achievements on it. You can copy and reformat as needed.

→ Post a copy on your web site.

EXHIBITIONS

List the most recent exhibition first, working backwards in chronological order. List date, title of exhibition, sponsor's name, city and state. If you've been in a lot of exhibitions, you can divide them into types of exhibitions—group shows, one-person shows, invitational shows, juried shows, upcoming exhibitions, touring exhibitions, museum shows. If you have fewer than three exhibitions, it's best not to break them into smaller groups.

RESUMES

Gallery owners are the people most interested in a resume. If you have nothing to put on your resume for a gallery, you probably aren't ready to show your work there!

2013	*Maximum Times*, Matrix Gallery, San Jose, CA
2011	*Beyond Time*, Scarborough Museum, Norwalk, CT
2009	*Now*, Soho Gallery, New York, NY

COLLECTIONS

You could divide this into private collections, corporate collections, public collections. You could donate one of your pieces to a museum and list it here.

JP Rundige Museum, Anaheim, CA

COMMISSIONS

List the date, title of the commissioned work, sponsor, and location.

| 2014 | *Benoit Park Sculpture,* San Francisco Art Commission, San Francisco, CA |

BIBLIOGRAPHY

List all the publications in which you have been mentioned or reviewed, including any articles that you have written. Quotes about your work can go here. Book entries should include author's name, title or pages of article, city of publication, publisher's name, and date.

It is not surprising that our city has taken such a liking to Katz!
San Francisco Chronicle, 2010

| 2011 | *Artwork at Bank of America,* San Francisco, CA; page 34, E P Dutton Inc |

AWARDS AND HONORS

List all awards and honors related to art: prizes won in competitions, project grants, artist-in-residence programs, fellowships.

| 2010 | *Purchase Award for Painting,* San Francisco State College, San Francisco, CA |
| 2009 | *Emerging Artists*, First Prize. Juror: Fisch, National Arts Club, New York, NY |

TEACHING AND LECTURING

Art-related only: guest lectures, workshops conducted, professorships

| 2013 | *Artist-in-Residence*, San Francisco Art Institute, San Francisco, CA |
| 2012 | *Instructor in sculpture and painting,* Marin College, San Rafael, CA |

AFFILIATIONS

List art organizations you belong to or community art activities in which you have participated.

2011 *Crocker Art Museum Liaison,* Sacramento, CA

EDUCATION

If you are a recent graduate, this category would be your first or second; otherwise, it is listed at the end (and in some cases not at all). List your educational credits in the following order: undergraduate degrees earned; graduate degrees earned; other institutions of higher education; notable artists you've studied with.

1977 BFA, San Jose State College, San Jose, CA

OTHER POSSIBLE CATEGORIES

Be creative—there are no rules carved in stone. Some possible categories:

Artist-in-Residence Scholarships Guest speaker engagements

Workshops conducted Featured artist Finalist in competition

Board of Directors Professional membership

You have never exhibited and have nothing to put on your resume? You need to start exhibiting and expose your work—enter competitions and juried shows, conduct private studio shows. You could list student shows under Exhibitions; scholarships and teaching assistantships under Awards and Honors. Be creative but honest!

MARLENA KATZ

UPCOMING SHOWS

2014 *My Time is Now,* Galleria Pace, Milan, Italy, one-person show

ONE-PERSON SHOWS

2012 *Venice at Dawn,* Bianca Gallery, Milan, Italy

2010 *Please Say Yes,* Academy Museum, Saleno, California

GROUP EXHIBITIONS

2012 *Send Me More,* Studio Trisorio, Naples, Italy

2011 *From Here to There,* Galleria Pace, Milan, Italy

2009 *American Icons,* More Gallery, Milan, Italy

2008 *Academy Museum,* Saleno, California

2007 *Continental Galleries,* Los Angeles, California

COLLECTIONS

Academy Museum, Mylara, California

De Pasquale Collection, Milan, Italy

Various private collections in Chicago, London, Rome, Venice, Amsterdam

PUBLISHED

2011 *Arte,* October

COMMISSIONS

2012 *Wall murals (in egg tempera),* private villas in Naples and Capri, Italy

2010 *Pair of folding screens for stage set,* Milan, Italy

12245 LEIBACHER RD, NORWALK, CA 93422 818.693.1444

CREATING AN ARTIST STATEMENT

An artist statement is an integral part of an artist's marketing process. It captures your philosophy so clients can better understand your artwork.

A correctly developed artist statement takes the reader to the heart of why you are an artist. It is a written dissertation of the idea behind your artwork, your personal philosophy—the aim of your work. It is not carved in stone and can change over time. It does not tell your life story.

Essentially, an artist statement expresses in writing what you have expressed in your art. It helps give collectors and interested patrons a better understanding of your artwork. Statements can also be helpful to reviewers and editors who write an article about your exhibition. A statement can provide psychological material from which writers can draw.

If you don't have a well-rounded resume, a well-written statement can sometimes influence a buyer in your favor. You want to show that you know what you are doing, understand your personal creative process, and believe in your work.

Brief statements—even one sentence—are fine, if that is what you decide to convey. The ideal length is no longer than four sentences or one paragraph. The shorter it is—one or two sentences—the more likely it will be read! Your statement can be printed on a separate sheet or combined on the same page with your resume. Regardless of the length, it must be well composed. Have an experienced writer edit your statement.

PHILOSOPHY

Within the statement, an artist is indicating to the public what she is trying to accomplish, what her aims are in sharing her work, her philosophy about life. The expression, as in painting, is sometimes abstract, sometimes religious, sometimes direct.

Start with a generic philosophical statement such as your emotional reasons for creating. Then broaden this thought to include your specific technique or subject matter. Keep these creative ideas simple so a non-creative reader can understand what you are trying to say: don't get caught up in artsy jargon that only art professionals will understand.

CREATING A STATEMENT

Start by just writing—rambling on about your philosophy—the reason behind your artwork. Don't think about what a statement "should be." Just write. You can condense it later. You'll not be able to compose a final statement in one sitting, so don't even try. It will take about a month or two of various sittings. Look at it every few days. Ask others to look at it. Ask a writer friend to edit, condense, make it more concise. Ask yourself:

▸ Why have you chosen to create your particular imagery?

If you have difficulty writing about your own work, perhaps you can find another artist to help you. You can write about him and he can write about you. Try whatever works. You could also pay for the assistance of a professional writer to summarize your philosophy into a cohesive statement.

▸ What is the role of color, texture, motion in your work?

▸ What medium do you use? Is there anything unusual about the way you employ it?

▸ Does emotional, social, or political content play a part in your work?

▸ What does your art say about your ideals?

▸ How do you feel when creating?

▸ How do you want others to respond?

▸ What are the key themes and issues of your work?

▸ Is there something that people don't understand about your work that you want to address?

Be intentional about the words you use. For example, "organized" is more powerful than "put together." Other good verbs to use are:

achieve	administer	advise	complete
coordinate	critique	develop	direct
establish	execute	formulate	gather
generate	implement	improve	initiate
instruct	introduce	invent	launch
lecture	manage	plan	research
review	select	solve	utilize

TIPS

→ Avoid "really," "very," "however,"

→ Be direct and concise.

→ Keep it simple—no poetic flights of fancy.

→ Take each sentence and try to explain it more clearly. Be as precise as you can.

TALK THE TALK, WALK THE WALK

In order to create a truthful statement, it is essential to know who you are and why you create the art you do. Any flickering lie or discrepancy becomes alarmingly large.

THREE ARTIST STATEMENTS

Art is the expression of a personal, sensual experience. An artist may communicate information, simple or profound, across time and space to the viewer, regardless of his background or epoch. My paintings have had success with an international audience from Rio to Tel Aviv. Do we speak the same language?

My artwork is dedicated to the vanishing species in Africa.

Five hundred years ago, a group of men working in Italy produced a genre of painting never since excelled. These painters from the Renaissance Period subsequently influenced in one form or another every painter. They firmly believed that Art's greatest role is to inspire and create higher ideals in people, to civilize humanity, nourish and protect the different ideas and myriad forms of culture. Anyone calling himself an artist today needs to have these thoughts at the back of his mind every time he begins a painting. Whatever happens during and after the efforts are made—if shaped by these ideals—can truly be called and acknowledged as Art.

BOOK REVIEW

Writing the Artist Statement, aptly subtitled *Revealing the True Spirit of Your Work*, is one of the only resources for art students, artists, and professionals explaining how to create a sophisticated, convincing statement about their art, while at the same time delving into the psychological reasons one is an artist in the first place. Working with artists daily, author and consultant Ariane Goodwin has been inspired to come up with a solution to every artist's nightmare—the dreaded request for an artist statement. Imagine! A 142-page book on how to write a two-paragraph statement. Needless to say, by the end of the book you ought to have a statement good enough to frame. Not only does this book explain why you need a convincing artist statement, it takes you step-by-step through the process of writing it, and tells you where and how to use it. *Writing the Artist Statement* not only helps you improve your overall writing and thinking, but also assists you in conquering some of the psychological fears associated with marketing your artwork, giving you more confidence in your art dealings.

Quote

"This book will push-start the process of writing a meaningful artist statement. It is motivating, reassuring, and provides an easy, workable approach that removes the barriers to writing your statement. This book is a great addition to every artist's reference library." Robert H McMurray, President of Federation of Canadian Artists

Excerpts

One artist I know sets her statement, printed in a large format with a taseful border, on an easel beside her work—her own mini-billboard. It never fails to attract an audience, who invariably read every delicious word before looking at her work. You can almost see the "aha" light of recognition in people's eyes, as what they view matches up with what they have just read. And to make sure they don't forget her, she prints the same statement on small business cards for people to take with them, whether or not they buy a piece of her work.

Some of the mistakes gallery owners saw over and over again in artist statments that blew through their doors:

→ Poor writing quality
→ Writing way too much
→ Using grandiose generalities to say nothing
→ Using overblown phrases

If you need more in-depth help with writing a statement, read *Writing the Artist Statement* by Ariane Goodwin. www.writingtheartiststatement.com

Making your mission statement is a very essential part of your marketing plan. It is also a vital part of your business's future success.

A mission statement is different from an artist statement. A mission statement is meant to deal with your business—what you want to accomplish by selling the art you create. Taking the time to create this will help you find your values, passions, and goals. It usually includes your company's function, products and services you provide, why you exist—values and beliefs, competitive advantages, goals and philosophies, and value system. Creating a mission statement helps you understand your motivation, which in turn helps state your aims more precisely.

Use the process of creating your mission statement as a learning tool for yourself. When you go astray, are down or lost in a muddle, reviewing this statement can help you refocus on what your aim was when you were in a more enlightened state.

Your initial statement should summarize where you are now and how that fits into your future aims. This statement is to be created over time. Edit, edit, and re-edit. Start with some questions:

Why am I an artist?

Why do I want to sell my work?

What's my primary aim for being an artist?

What do critics say about my work?

Define success for myself at this point in my life.

List expectations that I have for my art career.

List five people I admire and two adjectives to describe them.

What artists do I most admire?

List five traits in myself as an adult that I admire.

Define my artistic passions.

What are the strong points of my artwork?

What are the weak points of my artwork?

What are my personal marketing strengths?

What are my personal marketing weaknesses?

In what ways have I practiced persistence and perseverance?

What risks have I taken to advance my career?

In what ways have I made a total commitment to my art career?

A MISSION STATEMENT OF YOUR OWN

The mission statement for your business will give you a precise direction on what you plan on doing and where you plan on going in the future.

How have I used a rejection to my advantage?

What do my clients need?

Write down who you are and what you intend to be in your business. What do you intend to become? Your clients will want to know that you intend to be the next Rothko. What advantages will you offer? What benefits will you confer? Who is your ideal client? Who wants what you have to offer? Who is prepared to pay for it?

WORK-IN-PROGRESS

In answering the above questions you will be boiling down your random thoughts into a more organized compilation. Write anything that comes to mind. Work on this for a month or two. Eventually you will want to create an organized 250- to 500-word business mission. You can continue to edit and change, throughout your businesses life: It is a work in progress.

STEPS TO COMPLETION

Look into your vision further and try to see what the challenges will be. This takes time, in-depth quietness, and honesty. Perhaps you will find that you need some advice, some more investigation. This process will happen over and over again while you are open to new paths sprouting off from the original. Adapting, morphing, and reaching.

FINAL STATEMENT

Have a version of your mission statement that is 10 words, another that is 50 words, and yet another that is 100-plus words; all to be used under various circumstances.

TIPS

→ Note your statement in the present tense—what you are trying to accomplish now.

→ Don't fret about being "perfect"—there is no perfect.

→ The mission statement should not be clever or catchy, just accurate.

▸ This statement is a work in progress.

▸ Don't rush the process.

NEA

The National Endowment for the Arts was established by Congress in 1965 as an independent agency of the federal government. To date, the NEA has awarded more than $4 billion to support artistic excellence, creativity, and innovation for the benefit of individuals and communities. The NEA extends its work through partnerships with state arts agencies, local leaders, other federal agencies, and the philanthropic sector.

NEW YORK FOUNDATION FOR THE ARTS

Established in 1971 by the New York State Council on the Arts as an independent organization to serve individual artists throughout the state, the mission of the New York Foundation for the Arts (NYFA) is to empower artists across all disciplines at critical stages in their creative lives. We do this through three main program areas: cash grants and fiscal sponsorship, online resources, and professional development training.

LAGUNA FESTIVAL OF THE ARTS

Our mission is to promote, produce, and sponsor events and activities that encourage the appreciation, study and performance of the arts.

BECHTLER MUSEUM OF MODERN ART

The Bechtler Museum of Modern Art seeks to add significantly to the cultural landscape through exhibitions and programs that celebrate and explore the Bechtler collection of 20th-century modern art as well as the personal materials related to the collection that illuminate the unique role of the Bechtler family as patrons of the period's most innovative and influential artists.

FRANK LLOYD WRIGHT FOUNDATION

Educate and engage diverse audiences, including scholars, architects, students, scientists and the general public, through programs that encourage innovative thinking about the relationships between architecture and design and the natural environment, and inspire a quest for beauty, balance and harmony in the creation of buildings and spaces that enrich daily life. Preserve the works, ideas, and innovative spirit of Frank Lloyd Wright for the benefit of all generations: Educate, conserve, create. (see their vision statement on page 147).

PHILADELPHIA'S MAGIC GARDENS

Philadelphia's Magic Gardens (PMG) inspires creativity and community engagement by educating the public about folk, mosaic, and visionary art. PMG preserves, interprets, and provides access to Isaiah Zagar's unique mosaic art environment and his public murals.

EXAMPLES OF MISSION STATEMENTS

A VISION STATEMENT

A vision statement is an idealized, and possibly exaggerated, description of a desired outcome.

A vision statement takes into account the current status of your business and serves to point the direction you wish to go, creating a mental picture charged with emotion that can serve to energize and inspire you. The best vision statements aim at results five to ten years away, some look even further out. When developing your mission statement, focus on the desired outcome of the goal at its completion date. It will include values, morals, commitments.

As with Microsoft (see page 147), your vision statement can be a one-liner. If it's longer, you want to summarize by using a powerful phrase in the first paragraph of your statement. This will greatly enhance its effectiveness. If you are having trouble coming up with your summarizing phrase, conjure it up after you've written the rest of the vision statement.

DESCRIBE THE BEST POSSIBLE OUTCOME

The quality of your vision determines the quality of your ideas and solutions. A powerful vision statement should stretch expectations, taking you out of your comfort zone. Do you want to earn $25,000 a year—a half-time job—at selling artwork to relieve you of your present part-time job? Stretch yourself and go for $48,000—a full-time income—per year.

USE THE PRESENT TENSE

Describe your vision statement as if you were reporting what you actually see after your ideal outcome was realized.

ADD EMOTIONALITY

Not only should your vision statement describe how you will feel when the goal is realized, it should be infused with passion to make it even more compelling.

ADD SENSORY DETAILS

The more sensory details you can provide, the more powerful your statement becomes. Describe the scenes, colors, sounds, and shapes. Describe who is there and what everyone is doing. These sensory details will help you build a more complete and powerful mental image of your ideal outcome.

FRANK LLOYD WRIGHT FOUNDATION

The Frank Lloyd Wright Foundation will be a leading, global, multidisciplinary center for education, scholarship, debate, and research committed to the place of architecture and the arts in enriching the quality and dignity of life.

AVON PRODUCTS

To be the company that best understands and satisfies the product, service, and self-fulfillment needs of women globally.

MACY'S

Our vision is to operate Macy's and Bloomingdale's as dynamic national brands while focusing on the customer offering in each store location.

MICROSOFT

A personal computer in every home running Microsoft software

TOYOTA

To become the most successful and respected lift truck company in the U.S.

THE WALT DISNEY CORPORATION

To make people happy

STANFORD UNIVERSITY

Become the Harvard of the West

NIKE

1960s: Crush Adidas
Current: To be the number one athletic company in the world

IKEA

The IKEA vision is to create a better everyday life for many people. We make this possible by offering a wide range of well-designed, functional home furnishing products at prices so low that many people will be able to afford them.

FORD

Early 1900s: Democratize the automobile
Current: To become the world's leading consumer company for automotive products and services.

EXAMPLES OF VISION STATEMENTS

Chapter 14

Pitching the Press

Press releases

Formatting a press release

Story lines

Writing for the press

Meeting the press

Researching outlets

Everyone gets 15 minutes of fame.
Andy Warhol

PRESS RELEASES

To be the feature attraction in a positive article in your local newspaper says to the public that you are accepted. It imbeds confidence in potential buyers.

Andy Warhol clearly understood the power of publicity. Carmen Miranda made great use of its power. This power is often overlooked by artists. Artists must learn to understand the importance of "courting the press."

THE PITCH

Your "pitch" to the press—the press release—needs to be innovative and imaginative. Editors are bombarded by hundreds of press releases every week. Most editors complain about how incredibly b-o-r-i-n-g press releases are. You want to make your press release stand out in someone's memory. It's okay to use gimmicks, but don't be thoughtless. You might defeat your purpose.

A press release is the most common source of communication with a magazine or newspaper editor. Whenever there is a special event in your artistic career, notify the local art critics and newspapers about it. What is a special event?

Winning a prize in an art competition

Exhibition opening

A public or private commission

Tie-in event with a local charity

New method of painting you've discovered

Book you've written

Teaching a course at a college

A sale to a famous person

Giving a class, workshop, or seminar

Receiving a grant award

Donating artwork to a nonprofit organization

An inspiring press release might lead to a review of your work by a critic, an article, or a brief blurb directly from your press release in a local paper or magazine. If you do receive a review from an editor or critic, more likely than not it will be a favorable one.

Choose a potential publication to approach carefully. Know the audience and reason for their existence. Study back issues of publications to determine the slant, thus enabling you to understand how your subject matter can best benefit the editorial staff.

CREATE AN INTERESTING TITLE

▸ Rags to Riches: Five years ago this artist hadn't even sold one piece. Today, his work is in the White House.

▸ The Marriage of Venus and Mars: Two artists' creativity is more powerful than one.

▸ Warehouse Fire: Artist retrieves litho press and prints, but loses originals.

GIVE AN EXCLUSIVE

Tell an editor with whom you have a special relationship, that you will give him an exclusive on a story.

BE COURTEOUS TO YOUR EDITORS

When an editor is on deadline, it can be very stressful for him. Before you start "chatting," make sure he is not busy.

MOMENTUM

Use the power of momentum. When you receive press from one publication, let the others know.

Think of what your customers want to know about the event in your press release: write it for them. Be sure to post it online too.

FORMATTING A PRESS RELEASE

Keep copies of publicity photos online. Remember that storyline you sent your local paper? Well, it resurfaced and they want to do a short story. No time for a photographer to come out and photograph you. He needs the 5x7" yesterday!

You want to look professional when you send a press release to an editor, so you're going to imitate the big pros and follow the outline below.

For Immediate Release - These words are placed in the upper corner of a press release.

Contact Person - Underneath "FOR IMMEDIATE RELEASE," put your name (or your publicity agent's name), phone number, URL, and email contact. Make it as easy for the editor as you can to contact you.

Headline - You must think of a catchy title for your release. Make it clear and enticing. All caps and centered. Use the same headline for the subject line of your email blast.

Body Copy - The five Ws: Put the pizazz in the first three sentences.

> **Who** - State your business name or personal name

> **What** - Is it an opening, an exhibition, an open studio? Can you quote someone or give a testimonial from a celebrity? People love to read testimonials.

> **When** - State the exact hours, day of week, month, year

> **Why** - The main topic of your press release—why are you holding this event?

> **Where** - State the exact address, city, state, zip code, telephone number, and directions to an event.

Place the symbol "# # #" at the end of your release to indicate that there is no more copy. Anything placed below the three hatch marks is for the editor's information.

TIPS

→ Double-space with wide margins so the editors can make notes easily.

→ Make it concise—no more than one page. A small amount of information is easier to fit into that empty space within the newspaper.

→ Have both B&W and color reproductions in tiff format available to download online.

→ Start with local media. Cultivate the same media contacts consistently by sending updates on your career.

→ Try to get publicity if you are involved with or make a donation to a charity or professional organization.

→ Get on the publicity committee of an art organization or museum. This will help you meet the press.

SAMPLE PRESS RELEASE

FOR IMMEDIATE RELEASE

Contact: Shirley Katz www.shirleykatzart.com info@shirleykatzart.com 232.676.8732

EGGS MAKE ART

Shirley Katz will exhibit 12 of her unique egg tempera paintings in a one-person show March 18–25, 2013, at Kramer's Gallery, 1854 First Ave, Boston, MA. 607.731.2112. An opening reception honoring her will be held March 19, from 7:00 to 9:00 PM, and is free and open to the public.

Katz's technical mastery of this ancient medium—egg tempera—has gained her national recognition. She won the Best of Show Award in the prestigious Masters Show in New York City in 2012, and her painting *Angels* received the Outstanding Painting Award for technical merit at the Professional Painter's Show in Dallas, Texas, that same year. Her paintings are in the collections of prominent citizens nationwide and the Museum of Modern Art, Tampa, Florida.

Egg tempera, a medium usually associated with medieval and early Renaissance painters, is essentially pure pigment suspended in a binder of egg yolk. It is an opaque paint that dries very quickly, meaning that one layer of color must be "cross hatched" over another. This helps to create the glow that egg tempera gives to artworks, making it a perfect medium for realistic scenes.

#

Biography and photographs of Shirley Katz and her award-winning works can be downloaded at

www.shirleykatzart.com/pr

Pick five local contacts and woo them over a six-month period.

→ Follow up with phone calls, persistently but not harassingly. This is of prime importance and where most promoters drop the ball.

→ Know the names of art editors and reporters.

→ Often an editor will use your press release verbatim to fill a blank spot on his pages, so use your words wisely.

COMMON ERRORS

▸ Expecting immediate results

▸ Being a pest to the editor

▸ Sending out poorly edited materials

▸ Exaggerating and using superlatives or too many fancy words

▸ Being intimidated; the editors need your help!

A more advanced form of a press release is called a story line or feature story. Develop story lines to keep your local art editors informed. This type of story needs a hook, or a unique angle of human interest. You need a story that is new, different, and that the general public will be interested in. Is there anything happening in the news that is a hook to what you do? A holiday or anniversary to use as a connection? Brainstorm for ideas. Don't stop at just one! Write each idea on a separate piece of paper, adding both conservative and wild ideas until you come up with the hook. These kinds of stories are often carried by large local newspapers in the Sunday edition, so go for it! Spend time with this. It will ultimately pay off.

- One artist created paintings in her barn, wearing mittens during the long winter months. This somewhat simple, but unusual, story got her front-page coverage in her local newspaper.

- One artist sent a small bottle of "golden wine" to his local editor. His exhibit was entitled, "The Gold Country." Needless to say, he got a good response! It was also easy to follow up with a call to the editor because everyone remembered the gift and welcomed his call.

BRAINSTORM IDEAS FOR STORYLINES

LIST OF LOCAL PUBLICATIONS

Scan any clippings you receive in the local newspaper and put them online in a "Press" section. You might want to frame some of your press clippings. Enlarge them and mount them on your studio wall. It is impressive for visitors to see when you have an open studio.

Editors need news to produce their daily/weekly/monthly publications. Lots of pressure is put on editors to find new and exciting material. If you help an editor by providing him with a story line, you'll be one hundred percent ahead of the game. You will have a pal for life. Follow up. Remind him. Get to know him. You will get coverage.

STORY LINES

If you're going to have an exhibition at a gallery, you should be doing as much PR as you can, even if your gallery is doing some.

WRITING FOR THE PRESS

The aim of the press release is not necessarily to make sales, but to conjure up interest, memory and acceptance of your work, and possible attendance at an exhibit. To be known as an artist, you have to put yourself in a position to be seen. You need the public to hear your name (story) over and over.

Even though you are a visual artist, you will have to write some business items during your career: press releases, bios, artist statement, mission statement, vision statement. As creative as you are, you might be surprised at how good you are at writing, especially after you dedicate some time to the task.

HEADLINES AND SUBJECT LINES

You will need headlines for a press release, a title for your show, a subject line for an email blast. If this headline is not interesting, no one's going to proceed further and read more.

- Make sure the headline is about the story.

- Include an active verb: buy, now, pay.

- Keep it short.

- How to, free, new, as well as numbers work well: Seven Golden Rules to Buying a Painting.

- Long headlines are not as good as short, but if they get your message across, use them.

REDOS

Don't think that your first draft will be the end result. I sometimes sit on a written piece for several days, going back to it with a totally fresh mind, rewrite it and then do the same thing three or four more times, depending on the difficulty I am having or the importance of the project. In fact, that's how this book was written; over and over (and over and over), editing it week after week (and week after week) for several months.

- Edit, edit, edit, and then proofread.

- Whom are you writing to? Remember your audience at all times.

It is infinitely better to send out publicity and not have it used than to not send it out and miss an opportunity for it to be used.

The best place to start meeting the press is right in your home town. As your career starts, you must become familiar with the editors of your local publications, eventually meeting these editors in person through events that you attend. This will also give you a "rehearsal" period for learning how to deal with the big-time editors in larger, more-distant cities.

LIST OF EDITORS

Your list of editors should be compiled in a methodical manner. Don't forget to include in your list the specialty publications in your area such as: gallery guides, shopper guides, entertainment guides, neighborhood weeklies, alternative publications, religious newsletters, sports club publications, or civic publications. Because their budget and staff are limited, these smaller publications use lots of press releases. Most of these can be researched online.

Knowing the editorial deadlines could be the most important point involved. Monthly and weekly magazines have longer lead times than dailies, so you will need to send them press releases earlier than to daily newspapers. This can easily be noted on your database.

THREE'S A CHARM

It is often necessary to contact editors and important reviewers three times.

▸ A press release two months before the event

▸ An email invitation one month before the event

▸ A phone call two weeks before the event

PERSONAL WALK-THROUGH

If you are sending a press release for an upcoming exhibit, a reviewer might not want to come to the actual opening. He might want to view your work in a quieter setting—before or after the opening. Some artists suggest that the reviewer contact them for a personal tour of the exhibit. You could note this on your postcard in your personal handwriting.

A phone call one week before an event can be an added incentive for an editor to respond. Even a message on an answering machine might do the trick. Taking the time to invite the editor or critic personally to your opening or event can better the chances that he reviews your work by seventy five percent.

MEETING THE PRESS

Almost all artists who are selling nationally began (and are still) selling locally.

PERSISTENCE

Publicity must be constant. As one editor put it, "Think of yourself as the publicity director for a movie star." Persist, persist, and then persist some more. Persistence eventually pays in the PR world. When you continually send out new and exciting releases, it tells editors that this person means business! They'll take you more seriously.

FOLLOW-UP

▸ Try to speak to an editor personally.

▸ Try to catch an editor when he is not rushing to meet a deadline. Morning papers should be called mid-morning, afternoon papers mid-afternoon, TV after a broadcast.

▸ If they give you coverage, be sure to call and thank them, send a thank-you note, or both.

I once tried to get one of the artists I represented on a special news sequence. The producer was interested, but he constantly needed to be reminded. (TV is a hectic environment.) Finally, after 10 phone calls, without our being forewarned, a camera crew showed up for six hours one day to film the artist at work in the restaurant where he was restoring the cherub murals on the ceiling. A one-minute spot was on the news that night. Later we used the tape, along with another one the artist had from years before, on a VCR at an exhibit. People were quite impressed.

PR PHOTOS

Providing an outstanding or unusual visual will almost always get you PR. You know the old adage, "A picture is worth a thousand words." How many of us go through the newspaper "reading" the pictures?

BECOME "THE ARTIST" IN YOUR HOME TOWN

As a "service" to your community, write a quarterly article on art for your local newspaper or tourist magazine. Make sure you appeal to the "commoner," a person who might not know a lot about art, but who finds art and artists intriguing. Keep your articles fun, easy to read, and encouraging. Over time this will give you the authority that is needed to become known as "the artist" in town. It will definitely drive traffic to your studio and web site. Couldn't be better publicity! Possible topics:

▸ How to view art more effectively

▸ The importance of art in our schools

▸ Unusual venues to view art (sculpture gardens, visionary sites)

▸ Encourage the spread of original art, not just posters

GETTING PUBLICITY IN YOUR COMMUNITY

by Sue Viders

"I can't sell anything in my hometown. They don't understand my kind of art!"
Usually there are several reasons why your art isn't selling:

1. Your art might not be mature. You have not yet mastered the craftsmanship of your discipline and you actually are not ready to enter the marketplace.

2. Your art is ego-oriented. You create to please only yourself with no thought to the needs or wants of the potential consumer.

3. Your presentation is inadequate for today's marketplace. Perhaps your mats or frames are the wrong size, shape, or color, or they are poorly done.

4. You don't do follow-up work with clients.

5. You haven't done enough publicity to let the local buying public see your name and begin to appreciate your work.

6. Perhaps you don't do any marketing. You expect that clients will magically appear at your doorstep.

The grass is not greener in the other town. You will not sell better in another town or city until you learn how to handle the elements of your local publicity.

Start your marketing campaign with local publicity. Take the time to get to know the local editors and give them what information they want. The key is getting them to run photos. Since you are dealing with visually oriented people, photographs give an instant orientation to the editor on whether the information in the press release is newsworthy, of great interest to their readers, or whether it will fit into their publication's parameters.

Before you start any publicity campaign, do your own research locally.

→ Call each publication for their submission guidelines.

→ Study each publication. See what is happening, who the current editor and art critic are. Make sure you get the correct spellings of their names.

→ Clip out press releases and articles. Study and analyze them. Why were these articles used? What information did they contain? What was the main point they were talking about?

Exactly what are newsworthy ideas? Here are some suggestions:

→ An award or contest. The bigger the award, the more likely you will get in the paper.

→ Your work juried into an important show.

→ A demonstration or class. This might be great for the public to watch. Be sure to send pictures of this idea, so the editor has a feel for the overall viability of the story.

→ Be a sponsor of a special event.

→ What is unique about your studio space?

→ Give a Power Point presentation about your work and your philosophy.

Used with permission of Sue Viders. Contact her at www.sueviders.com.

RESEARCHING OUTLETS

Even very famous artists go after publicity whenever they can. Rauschenberg hired a PR firm when he had a retrospective at a museum. The museum had attempted to get him some local PR, but he wanted national PR. He knew that if he spent money on PR, his name would receive more worldwide recognition.

Keep in mind your particular style, medium, and subject matter when looking for a source of national publicity. Are you a painter of tulips? There are tulip societies, and thus magazines, that might be just the right place to start rounding up publicity.

When you learn about appropriate national magazines for your genre of artwork, send the editor a storyline-type press release. The key factor, remember, is the relationship between your subject matter and the needs of these editors.

TIPS

→ Target your client base.

→ Increase your community involvement to build friendships and loyalty.

→ Update and categorize your mailing list so your clients get the right information.

→ Get involved with corporations and interest them in collecting.

→ Stay on top of the news; timing is everything in planning, perhaps you will have a tie-in.

→ Follow up, follow up, follow up to service your clients (the editors in this case).

→ Make the editors feel important by listening to their needs, wants, and desires.

Chapter 15

Creating the Plan

A personal plan

Setting goals

Starting point

Ideas to get your marketing going

Risk value

Explore a goal

Examples of long- and short-term goals

No one ever regarded the first of January with indifference.
Charles Lamb

A PERSONAL PLAN

Each January, set one or two major business goals for the coming year.

Congratulations! You've studied chapters 1–14. Now the fun part begins: You get to analyze and write down your goals, then proceed to accomplish them.

A PLAN FOR YOUR BUSINESS

A business plan is the process of analyzing and planning how you can more effectively reach your potential buyer. A plan includes developing a series of creative strategies that get your artwork seen by a buyer, therefore increasing your chances of it being purchased. No one business plan will make you rich and famous overnight. You must see marketing as a serious commitment or nothing will happen. As you already have figured out, marketing takes time, energy, and money.

A business plan is a requirement in any business if there is to be hope of success. Without a plan, results will be erratic at best. A business plan is your personal road map to success. The professional artist cannot afford to be complacent about creating a comprehensive plan.

Developing a business plan does not have to be an overwhelming task. It does take thinking and soul-searching—sitting down in a quiet mode, concentrating and brainstorming. You will be making some serious judgements and commitments.

CREATING A PLAN THAT FLIES

When you create your business plan, you must have realistic goals, taking into consideration your cash flow and time constraints. Do not compare your plan with someone else's; this is ludicrous. If you have only four hours a week to market, you cannot compare yourself to the person who is devoting twenty hours a week to the same task.

Any business must be thought about over the long term. There is no short-term business. You must have a good overview of what your aims are—creating your vision statement helped with this—although they will certainly change over time.

Try to understand why you must devote some time to developing a business plan.

▸ Concentrating with conviction on a particular direction, one often attracts that which one is aiming at.

▸ A plan will help you diagnose difficulties you need to overcome in order to reach your final destination.

▸ A plan helps you budget—both time and money—better, by anticipating the future.

DEVELOP YOUR PLAN

▸ Keep your plan flexible.

▸ Know your target market. Be aware of techniques to reach your particular market.

▸ Know your budget.

▸ Understand the benefits of your product.

▸ Write in pencil—you will update your plan as time goes on. It's an ever-evolving plan.

▸ Give each goal its own life—write it down on a separate piece of paper. List each strategy on a separate piece of paper. Pin them to your studio wall. Revise as necessary. Keep the individual goals simple. Use baby steps.

All of these ideas have been covered in the previous chapters. Hopefully you have dedicated some time and serious thinking to them and are ready to proceed.

You need a written business plan:

▸ To define new and innovative promotional avenues based on a better understanding of resources available and your particular strengths.

▸ To maximize your desired results by developing numerous solutions and contingency options.

▸ To make better use of your budget by planning and analyzing cost-effective options.

Some important questions to think about, relative to your marketing habits, follow. Figure out for yourself what type of schedule works best for you. Write it out so you can adhere to it; what works best for you?

How many hours per week have I spent marketing during the last six months? ____

I will commit to __ hours per week in the next six months. _____

I will use a calendar to keep track of marketing time and appointments.

I will market at a specific time each week.

Establish your goals in incremental periods of time, long-term towards short-term.

FIVE FACTORS FOR SUCCESS

These five factors came about by studying successful artists' approaches to daily tasks. As you make your goal-setting chart, keep these five factors in mind.

1. Continually contacting people

Make it a goal to call four people a day—whether they be new prospects or current clients. It's guaranteed that not only will you become quite good on the phone, but your business will flourish. Clients are the mainstay of any business. Don't have long conversations; in fact, they should be short, with a specific goal in mind. You could ask for referrals, invite the person to visit a future opening or exhibit, invite him to your studio to see your new series of work, thank someone for a recent purchase. Be creative! Add to this list of four phone calls a day, four postcards per day, and you have eight contacts a day, to get a total of 40 contacts a week! If you try this for two months (320), you will be amazed at how your sales increase.

2. Follow-up

Not only do successful artists follow up after they contact someone, but they follow up even if they receive a rejection. This means that they send out a postcard with one of their images on it, a photo print, announcement of an exhibition, whatever it is—at least every six to twelve months to all prospective clients, galleries, and former purchasers. The rule in direct marketing is: You must contact people three times before they respond! As an artist, you won't have a huge mailing list; it will be quite intimate, perhaps 50–100, so the cost to do a mailing is not overwhelming. Email broadcasts can be used as well.

3. Innovative marketing

Successful artists are always thinking of innovative ways to market. Be willing to take a risk if you feel a new idea might work. For instance, new places to exhibit—an orchid show, an interior design show, a real estate show, a music conference, a sci-fi convention— whatever you think might work. Presentation is always consistent and top-notch, of course.

4. Press coverage

Successful artists consistently receive press coverage. Although she might not get direct sales from this press coverage, a successful artist knows that in the long run it means many people see her name, artwork, and progression over the years. This means a lot to potential buyers. It also means that the newspaper/magazine approves. Name recognition is of the greatest importance in any business.

5. Long-term goals

All the successful artists I know have long-term goals. They planned and strategized to get where they are today. They never gave up. They knew their target and they knew there would be down periods, as in all businesses. Their goals kept them going: goals are the mainstay of any business.

It is said that 90 percent of businesses that don't have a formal, written plan, fail. Do you want to be among this 90 percent? If you don't have a destination, how will you know when you get there?

A goal is a specifically defined objective, not a wish, dream, or desire; such as "I wish I were famous," or "I wish I could get into the next watercolor show." Try to be as specific and detailed as you possibly can in thinking about goals. Consider what you want financially. Are you also looking for prestige, press coverage, peer recognition, a speaking engagement?

Some people advocate setting targets that you can easily reach so you won't fail. This type of goal might limit your possibilities. How do you know you can't do more if you don't try? Others recommend setting goals that are a bit beyond what you think you can accomplish. This type of goal could drive you to be more creative, pushing you into new territory (and risk taking), or it could make you feel like a failure. You have to know your own needs in this department and then apply appropriate pressure.

TIPS FOR DAILY SUCCESS

→ Focus on top-priority tasks every day. If you are able to accomplish your number-one task, then you've had a productive day. Strive for a balance between quality and quantity.

→ Use weekly and daily to-do lists. Cross out tasks that you've completed on your daily list. If need be, stamp "completed" on it. That can give one a feeling of accomplishment.

→ Imagine yourself in your role as art entrepreneur and you will be more prepared mentally to succeed.

Let's think about general goals and directions for your art business, and then about particular aims as steps to reach those goals. On the following pages are some aims to consider. Add some of your own.

SETTING GOALS

Planning helps us, especially those of us who work alone. It will give direction to chaos.

STARTING POINT

The biggest step in becoming successful is to start working your plan!

If you have not already started making lists of what you need to start with, now is the time. Following are some examples. If you've already accomplished them, great! You can cross them off the list. It always feels good to cross off a finished project!

- ▸ Figure out my main roadblocks and weaknesses (pages 14–15).

- ▸ Sign off on a commitment letter to myself that states how many hours a week I will devote to my business (page 29).

- ▸ Create an office environment (pages 32–35).

- ▸ Check out software programs for artists (page 33).

- ▸ Start keeping track of income and expenses (pages 47–48).

- ▸ Document the artwork I've created to date (page 42).

- ▸ Create a projection of income for my business (page 51).

- ▸ Brainstorm a business name, tagline, and logo (pages 122–124).

- ▸ Get a business license (page 24).

- ▸ Open a bank account for my business (page 24).

- ▸ Get a sales tax permit (page 24).

- ▸ Copyright my artwork to date (page 64).

- ▸ Create a user-friendly sales document (see page 70).

- ▸ Evaluate my pricing (page 76).

- ▸ Sign and title all my work (page 82).

- ▸ Look for a place to have an exhibition (page 98).

- ▸ Get a PayPal account (page 106).

- ▸ Start planning a web site (or update) (pages 108–115).

- ▸ Start working on my artist, mission, and vision statements (pages 139–147).

- ▸ Create a five-year marketing plan (pages 173–176).

The following marketing ideas include both short- and long-term goals. Long-term goals need to be revised annually. They will change as your business grows. Once you have written down your strategies, take out your annual planning calendar and break them down to the month, then week, then day. Give yourself time to accomplish each task, but not too much time! Organize, preferably on a calendar, the process and timing each part of your task will take to complete. Set a firm deadline yet make it realistic. Anticipate delays. Often it takes twice as long as you expect, but that's great—at least it's done. And don't worry about revising; this is simply a plan, not a life and death situation.

▸ Spend one day visiting local galleries.

▸ Approach a gallery for a show.

▸ Have a group show with some other artists.

▸ Try to get an article in a magazine.

▸ Investigate teaching an art class.

▸ Host a private studio show: For what special seasonal event can you open your studio?

▸ Investigate doing a fine art fair: Attend an outdoor show to check it out for possible exhibition next year.

▸ Approach a cooperative gallery to become a member.

▸ Approach a business to lease your artwork to.

▸ Keep eyes open for a museum show for emerging artists.

▸ Investigate interior designers in the immediate area: What interior designer could you take to lunch?

▸ Investigate getting a rep.

▸ Display at model homes.

▸ Approach a print publisher.

▸ Do show and tell lecture at your local Chamber of Commerce.

▸ Start compiling names for in-house mailing list.

▸ Call five to ten art professionals each week.

▸ Organize a solo exhibit.

▸ Subscribe to an art publication for one year and read it.

▸ Enter an art competition.

IDEAS TO GET YOUR MARKETING GOING

You should be keeping a file of ideas you have throughout the day. Write these ideas down: Believe me, you won't remember them otherwise!

- ▶ Help sponsor a community event with a nonprofit organization.
- ▶ Conduct a client survey to see what products your clients would like.
- ▶ Donate time to some nonprofit; let people know you are an artist.
- ▶ Barter your art for a service.
- ▶ Enlarge your Yellow Page ad.
- ▶ Support your statewide arts organization by buying an art license plate. Put something related to your business name on it.
- ▶ Make a special offer to your clientele.
- ▶ Try to get an interview on your local radio station.
- ▶ In what cafe could you hang your paintings?
- ▶ Give out coupons with your next Christmas card.
- ▶ What special offer could you make on a postcard to your clients?
- ▶ What story line can you create for the local newspaper?
- ▶ What art idea could you write a story about?
- ▶ What previous client would be able to give you a useful referral?
- ▶ What "stunt" can you think up to give yourself some publicity?
- ▶ What sign could you put on your car to advertise your work?
- ▶ What bumper sticker could you create to give to your clients?
- ▶ Attend your arts council's next open house.
- ▶ Create an email newsletter to send to clients.
- ▶ Which one of your art pieces would make the best Christmas card?
- ▶ How much would it cost to put up a billboard at the entrance to your town?
- ▶ Create an unusual, catchy name for your new group of paintings.
- ▶ Find a marketing mentor; treat him to lunch.
- ▶ Refer business to one of your clients.
- ▶ See if a client would be willing to have an "art party."
- ▶ Have your answering machine say something memorable (but brief!).
- ▶ Provide a specialized service that no other artist provides.

- Get a phone number that spells out something (or figure out what your current one spells).

- Befriend a competitor.

- Work with a local chapter of American Society of Interior Designers: give a talk at one of their meetings.

- Rent a booth at a home show.

- Place a display of your work at the local library associated with the talk you will give.

- Rent a truck and create a travelling exhibit in the back.

- Contact your closest concert hall and rent artwork to them.

- Find a Realtor's office that will let you exhibit. They have a lot of new homeowners walking through their facility. Offer the agent who sells a piece a 30–50 percent commission.

- Create a gift certificate form to sell to clients.

- Ask for written testimonials from your favorite buyers.

- Check out your local doctor, veterinarian, optometrist, emergency room, hospital, medical facilities office. These venues can prove to be excellent choices and often do have a budget for "decoration." If they are not in the position to buy, offer a lease.

- Connect with your American Institute of Architects local chapter; give them a talk at their next local meeting about your artwork.

RISK VALUE

Once you choose approximately five goals, classify them into low- to high-risk categories. In this way you can see that if all are high risk, it will be a longer trek than if three were high risk and two medium risk. It's best to have some goals in each of the risk categories. That way you can encourage yourself along by finishing some goals easily, adding more while still working on your higher-risk goals.

LOW RISK

▸ Donate artwork to a charity.

▸ Design a better business card.

▸ Figure out a tagline.

▸ Subscribe to an art publication.

▸ Visit another artist's studio.

MEDIUM RISK

▸ Cold call a gallery.

▸ Hold an open studio.

▸ Send a press release to a local paper.

▸ Give an art demonstration.

▸ Join a co-op gallery.

▸ Initiate exhibits at the local auto dealership.

HIGH RISK

▸ Join the state arts council.

▸ Ask for referrals from previous clients.

▸ Suggest an article to the local art critic.

▸ Develop a series of lecture.

▸ Teach a class.

▸ Create a web site.

EXTRA-HIGH RISK

- ▸ Create an art event for your community.
- ▸ Hire a rep.
- ▸ Give a solo show.
- ▸ Develop a press packet.
- ▸ Write a book.
- ▸ Do a national seminar.
- ▸ Consider advertising.
- ▸ Publish a print.

BRAINSTORMING

Where do I want to be in 10 years? _____

Where do I want to be in 5 years? _____

Where do I want to be in 1 year? _____

How much money do I want to make this year? _____

How much money do I want to make in 5 years? _____

How much money do I want to make in 10 years? _____

THREE STORIES OF INNOVATION

A gallery furnished a popular restaurant with framed prints which were for sale at the restaurant. The gallery installed a direct phone line—Art Hot Line—linked directly to the gallery, from which customers at the gallery could order. This brought in one to two sales a week.

A couple of nonprofits have created a fund-raiser by publishing decks of playing cards, with their members' art on them.

The Fiber Artists Collective sends out an annual postcard deck of its members. It's hard to resist going through the packet of 30–40 postcards—they're so beautiful.

EXPLORE A GOAL

BREAKING DOWN GOALS

The next aspect of looking at your goals is to break down each main goal into smaller tasks. For example, your main goal is to open up a business bank account:

▸ Get a fictitious name permit.

▸ Publish fictitious name in paper.

▸ Get bank account and ATM card with fictitious name permit.

Main goal is to design a postcard:

▸ Know the purpose of the card.

▸ Get quotes from printers; decide what type of paper.

▸ Determine cost of mailing; plan whom to mail to.

▸ Write copy; will it have an order form?

▸ Arrange for appropriate photos of artwork.

▸ Hire/trade with designer to work on postcard.

Okay, now that you understand the idea of goals better, let's take one of your possible goals and break it down.

Specific goal _____

Risk level _____

Cost involved _____

Time involved _____

To-do tasks _____

Conservative approaches _____

Medium risk approaches _____

Wild approaches_____

TWELVE-MONTH GOALS

1. _____
2. _____
3. _____
4. _____

STEPS TO REACH GOAL 1

1. _____
2. _____
3. _____
4. _____

STEPS TO REACH GOAL 2

1. _____
2. _____
3. _____
4. _____

STEPS TO REACH GOAL 3

1. _____
2. _____
3. _____
4. _____

STEPS TO REACH GOAL 4

1. _____
2. _____
3. _____
4. _____

Download and print out a copy of this form at www.artmarketing.com/artoffice/marketingchart.pdf

EXAMPLES OF LONG- AND SHORT-TERM GOALS

FIVE-YEAR GOALS

1. Get accepted into a San Francisco gallery as one of their stable.

2. Net $35,000 from my business.

3. Exhibit at ArtExpo.

4. Get printed by an established publisher.

FOUR-YEAR GOALS

1. Invite 200 people to my Open Studio.

2. Donate a piece of artwork to charity; use this opportunity for PR.

3. Net $25,000 from my business.

4. Exhibit at three fine art fairs.

THREE-YEAR GOALS

1. Have a mailing list of 30 purchasers as well as 100 possible purchasers.

2. Net $20,000. Go part-time on my regular job.

3. Investigate art publishers.

4. Exhibit at an art show.

SECOND-YEAR GOALS

1. Invite 100 people to my Open Studio.

2. Advertise in the Yellow Pages.

3. Net $15,000 this year.

4. Research corporate art consultants.

FIRST-YEAR GOALS

1. Become a legal business.

2. Prepare an outstanding web site.

3. Find an interior designer with whom to work.

4. Hold an exhibit at my studio.

STEPS TO REACH GOAL 1

1. Decide on company name/logo.

2. Design business card.

3. Get business license/sales tax permit.

4. Market 10 hours a week.

STEPS TO REACH GOAL 2

1. Take digitals of all artwork.

2. Prepare a resume.

3. Plan my web site's overall appearance.

4. Hire a designer and learn what I can from him.

STEPS TO REACH GOAL 3

1. Call five interior designers.

2. Get an appointment with an interior designer.

3. Study Decor, Art Business News, Interior Designer Magazine.

4. Explore a merchandise mart.

STEPS TO REACH GOAL 4

1. Create a 12-month plan for my Open Studio event.

2. Frame work.

3. Find a salesperson.

4. Get studio in order: clean, paint, scrub!

FIVE-YEAR GOALS

FIVE-YEAR GOALS

1. _____
2. _____
3. _____
4. _____

FOUR-YEAR GOALS

1. _____
2. _____
3. _____
4. _____

THREE-YEAR GOALS

1. _____
2. _____
3. _____
4. _____

TWO-YEAR GOALS

1. _____
2. _____
3. _____
4. _____

THIS YEAR'S GOALS

1. _____
2. _____
3. _____
4. _____

Download and print out a copy of this form at www.artmarketing.com/artoffice/marketingchart.pdf

Bold type = Companies, authors, organizations

Italic type = Publications

Bold type = Companies, authors, organizations

Italic type = Publications and videos

Art Travel Guide

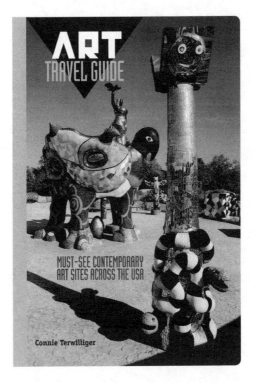

Put this paperback treasure in the car glove compartment, or your backpack, or on any reading device. Filled with colorful photos of stunning art sites located across the United States, these images will both entrance and amaze you. The startling sculptures displayed against placid greenery or reflecting waters provoke imagination and trigger wonder. Sculpture parks are dotted across the country. Travel to Pennsylvania to view Andy Warhol's work, or visually step on "The Helical Staircase" in the Florida Dali Museum. In Los Angeles, the Watts Towers sharply points to the sky like church spires. Constructed from recycled scraps over a thirty-year period, the edifice is a testimony to one man's passionate obsession. Architecture is not ignored, and Frank Lloyd Wright's landmark buildings can be viewed in Marin County, Arizona, Wisconsin, and elsewhere. The controversial Disney Concert Hall in Los Angeles by Frank Gehry bemuses the eye, while the unconventional Seattle Public Library delights the visitor.

Our academic institutes are repositories of art in its myriad forms. The reviews of these many sites of contemporary art that are accessible to the public in parks, museums, city lots, campuses across our bountiful country whet the desire to become immersed in the settings. The running narration clarifying the history, personalities, quirks, and perks of each place further enriches this art guide. The table of contents divides the sections into sculpture parks, visionary sites, campuses, art centers, and more. A helpful state-wide index is provided. *San Francisco Book Review*

128 pages 6x9" 978-0-940899-56-8 $16.95